The College History Series

CONVERSE
COLLEGE

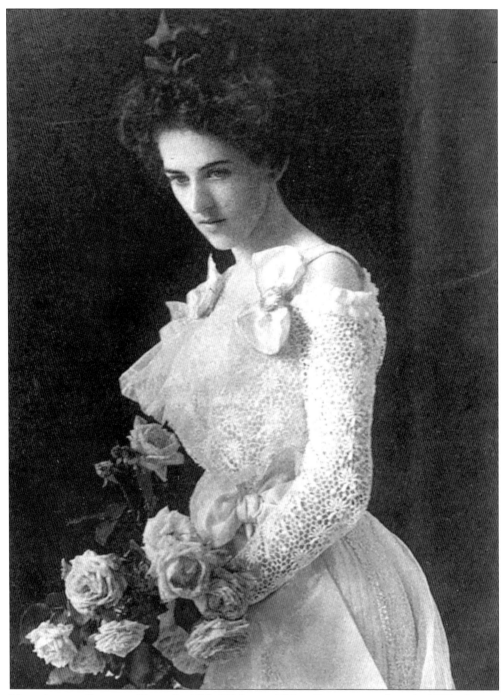

MARIE ALBERTA CONVERSE. The only child of Helen and Edgar Converse was born in 1875, 19 years after the marriage of her parents. She was named "Alberta" after her uncle, Albert Twichell. It was Marie's birth that later interested her father in founding a local college for women. Married to New York physician William A. Downs, Marie died in 1907 at the age of 32. She had one daughter, Helen Converse Downs. Her widowed husband remained a college trustee and contributor for 41 years after her death.

The College History Series

CONVERSE
COLLEGE

JEFFREY R. WILLIS
ANDREW HELMUS DISTINGUISHED PROFESSOR OF HISTORY

ARCADIA

Published by Arcadia Publishing,
an imprint of Tempus Publishing, Inc.
2 Cumberland Street
Charleston, SC 29401

Printed in Great Britain.

Library of Congress Catalog Card Number: 2001094278

For all general information contact Arcadia Publishing at:
Telephone 843-853-2070
Fax 843-853-0044
E-Mail sales@arcadiapublishing.com

For customer service and orders:
Toll-Free 1-888-313-2665

Visit us on the internet at http://www.arcadiapublishing.com

This book is dedicated to the students of
Converse College—past and present.

(*on the cover*) CRESCENT. Crescent is a sophomore honor organization dedicated to scholarship and service. The members for 1966–1967 are shown in the cover photograph.

4

CONTENTS

ACKNOWLEDGMENTS

Most of the images in this book came from the Converse College Archives. James Harrison, the college archivist, gave me a free run of the archives and unrestricted use of the collection. I am indebted to him. I am also indebted to the many people who have contributed photographs and other material to the archives; I encourage others to continue to do so in the future. Another source was the Converse Office of Information. Beth Farmer and the staff were very helpful. I am grateful to the alumnae who contributed photographs: Martha Paxton Beale, Ann Richards McCall Crenshaw, Martha Lynn Mercer Gaskins, and Amy Booth Allred.

When I joined the faculty in 1967, Dr. Lillian Kibler, retired chair of the History Department, was living in the guest apartment of Williams Dormitory and working daily in the library on her *History of Converse College*. I was privileged to know her and have benefited extensively from her scholarship in preparing this volume. Other individuals long associated with Converse have shared their knowledge—especially Alia Ross Lawson, Mary Lib Spillers Hamilton, Charles H. Morgan, and Robert T. Coleman Jr.

Bobbie Daniel and Melissa Daves Jolly in the Alumnae Office looked over the entire text and photograph selection and offered suggestions from the perspective of the alumnae. Their assistance throughout the project was invaluable. Elizabeth Simons was also helpful, as was Adelaide Capers Johnson. Many other graduates and faculty have contributed information. All of those mentioned are responsible for the better features of this publication. The mistakes and misjudgments are those of the author alone. I should also express gratitude to the many members of the college staff and faculty who, under duress, shared my delight in discovering especially unique photographs. They were kind not to run.

I appreciate the approval and moral support provided by President Nancy Gray, Provost Thomas McDaniel, and Dean Joe Ann Lever. Laura Daniels at Arcadia Publishing provided valuable editorial and technical assistance.

INTRODUCTION

This pictorial history follows a chronological theme rather than a topical approach. It is hoped that the reader, while turning through its pages, will be able to visually trace the evolution of this historic institution and the many changes its campus and students have undergone over a period of 112 years. Every decade of the college's existence is represented. Founded in 1889 to educate young ladies, Converse today strives to prepare young women for careers and to equip them to face a world that presents far different challenges than those of the 1890s.

Every effort was made to identify as many photographs as possible; from these were chosen a few hundred images that could be accommodated within a format designed to produce an easily digestible and affordable volume. Identifying approximately 3,000 photographs was probably the most time-consuming part of the process. Then came the difficult task of deciding which to include and (still worse) which to leave out. An effort has been made to fairly and equitably chronicle all aspects of the college's life and development. Basically, it has been necessary to work with the available photographs and to try to make them fit into a coherent narrative of the history of Converse College.

One goal of the project has been to document campus buildings that are no longer standing and those that have changed in appearance and function. However, the heart of the institution has not been the buildings, but the human beings who have led, taught, studied, cleaned, and repaired within its gates. Space has been allotted for them. It has not been possible to include everyone who deserves inclusion. The best that could be done was to select representatives from the time period dealt with in each chapter. Once again, the selection was governed by the images that were available. Those who are currently learning and teaching will earn a place for themselves in subsequent volumes.

It is hoped that the reader will find the captions informative and useful, and that the book will serve as a quick reference source. Naturally, space limited the amount of information that could be included. Alumnae may find this volume to be a happy, and sometimes poignant, journey back to their student days. Current and future students will discover in these pages aspects of their college's past which they would otherwise never see or know about. It is hoped that all will enjoy the effort.

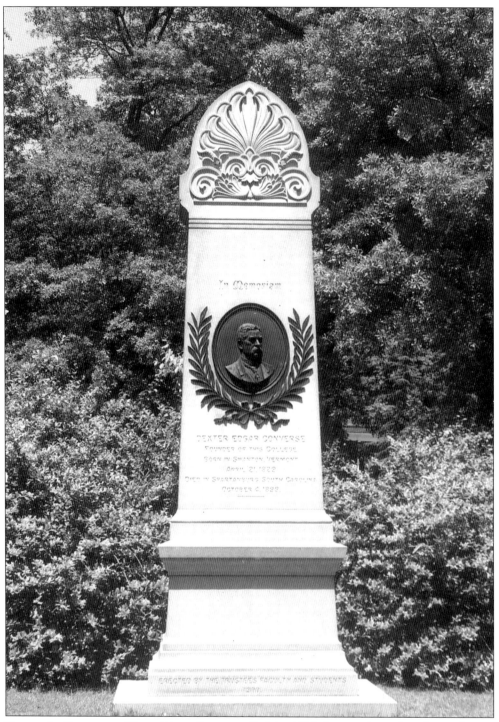

In Memoriam

DEXTER EDGAR CONVERSE
FOUNDER OF THIS COLLEGE
BORN IN SWANTON VERMONT
APRIL 21 1828
DIED IN SPARTANBURG SOUTH CAROLINA
OCTOBER 4 1899

ERECTED BY THE TRUSTEES FACULTY AND STUDENTS
1903

FOUNDER'S MONUMENT. When Edgar Converse died in 1899, he was buried in front of Main Hall, as he had requested. Later Helen Converse had her husband's body re-interred in nearby Oakwood Cemetery. The monument above was placed just inside the main entrance to the college.

8

One
FOUNDING AND EARLY YEARS
1889–1920

In the 1880s and 1890s, the construction of large textile mills established Spartanburg as a major textile center. An important connection would develop between these textile mills and the expansion of educational opportunities in the community. As the future of Spartanburg grew brighter, some of its citizens became concerned over the lack of educational opportunities for young women.

In 1855, the Spartanburg Female College was founded, as a joint effort of the South Carolina Methodist Conference and citizens of Spartanburg. The school, however, did not prosper and closed in 1872. The same leaders who had spearheaded Spartanburg's industrial expansion in the 1880s then stepped forward and used their talents and resources to found a college for young women. A member of this group was a 33-year-old lawyer, Henry Edmund Ravenel. He invited other town leaders to a meeting at his law office on Magnolia Street on March 22, 1889. At this meeting the decision was made to raise funds to found a college for women. A week later, the new institution was named Converse College in honor of Dexter Edgar Converse, who was a leading textile executive and a major contributor.

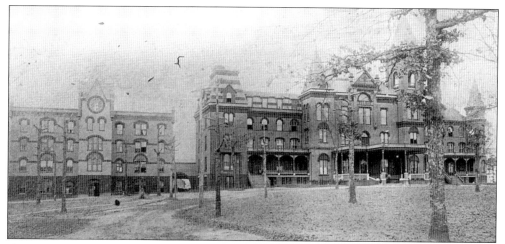

THE ORIGINAL BUILDINGS. In 1889, the trustees of the new college purchased the St. John's College property from the Episcopal Diocese. The site had been the location of several attempts to establish an Episcopal school, first for boys and later a theological seminary. On the property was a chapel and two completed wings of a proposed main building. The college trustees completed Main Hall and erected an annex (shown on the left in this view), which was later renamed Pell Hall. The original entrance of Main Hall lacked a porte-cochere.

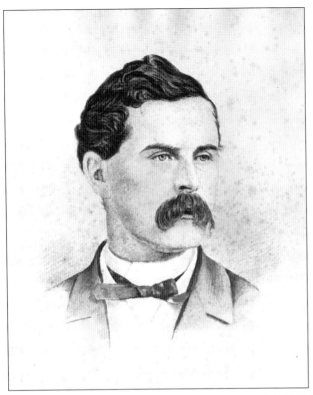

DEXTER EDGAR CONVERSE. Edgar Converse was born in 1829 in Swanton, Vermont, into a family that was already involved in woolen manufacture. His education was not extensive, but he grew up with a thorough knowledge of machinery and management of a mill. Realizing the potential for developing textile manufacturing in the southeast, he migrated south in 1854 to work for a cotton mill in Lincolnton, North Carolina. In 1855, he was attracted to a job at the Bivingsville Cotton Factory near Spartanburg, where he was hired as a superintendent. In 1870, he bought the mill and changed the name to D.E. Converse & Company. In 1882, Converse established Clifton Manufacturing Company, which grew to include three of the largest textile mills in the South.

HELEN TWICHELL CONVERSE. After being hired at the Bivingsville mill, 27-year-old Edgar Converse traveled back to New England, in 1856, to seek a bride. His choice fell on his 17-year-old first cousin, Helen Antoinette Twichell. She was the perfect wife for a young man on the rise. She was better educated than her husband and of a sociable nature. They lived in an imposing, colonnaded house overlooking the mill at Bivingsville. After her husband became owner of the mill, Helen Converse changed the name of the village from Bivingsville to Glendale. No children were born to the couple for 19 years. Following the birth of their daughter, Marie, in 1875, the family built a Victorian mansion on Pine Street in Spartanburg.

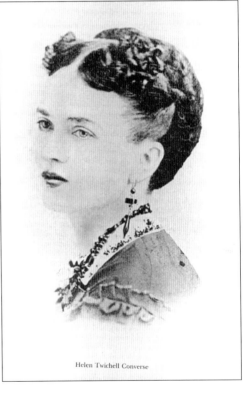

Helen Twichell Converse

THE FIRST PRESIDENT. In 1890, the Board of Directors called upon the minister of the First Presbyterian Church, Benjamin Franklin Wilson (shown to the right as a young man), to accept the role as the college's first president. Wilson was described as having a missionary zeal to serve humanity. This translated into a deep interest in each individual student at the new college. During the 12 years (1890–1902) that he served Converse, he set the pattern for later leadership with an emphasis on growth and high standards. A bond developed between Wilson and Edgar Converse that verged on a father-son relationship. Mr. Converse provided valuable support for the young president. Early in 1902, Wilson left Converse to pursue further study in Europe and at Harvard University. In 1905, he became minister of the First Presbyterian Church in Harrisonburg, Virginia, where he remained for 27 years. In 1929, Main Hall was renamed Wilson Hall.

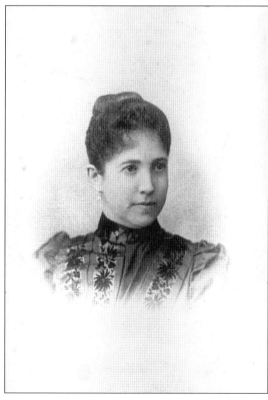

SALLIE WILSON. The college directors were concerned that B.F. Wilson was only 28 when he became president and was unmarried. Several months later Wilson married Sarah Gist Farrar Foster, a young widow from his former congregation. She had been raised on a large plantation at Pinckneyville in Union County. As a girl she had attended Stuart Hall in Staunton, Virginia. She became a valuable associate of her husband in the performance of his new duties. When the marriage ended after more than 40 years with B.F. Wilson's death in 1932, Sallie Wilson wrote to a nephew "the light has gone out of me." She was heart-broken and died a few months later the same year.

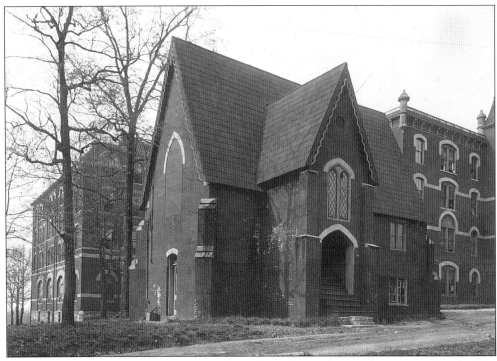

St. John's Chapel. The Episcopal Diocese of South Carolina and Rev. John D. McCollough of the Episcopal Church of the Advent in Spartanburg had made several attempts to establish an Episcopal school on property east of the town of Spartanburg. A little chapel was the only completed building of St. John's Theological Seminary. Since the new college had an ample chapel on the second floor of Main Hall, St. John's Chapel was used as a science laboratory. It was demolished in 1915 to build Judd Science Hall. Today, there is a gazebo on the site.

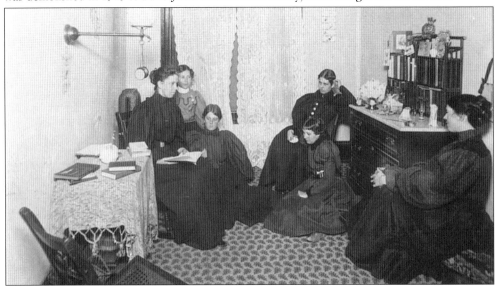

Early Dormitory Life. The residence rooms in Main Hall had the most up-to-date gas lighting fixtures. Students were not the only occupants—it was also the residence of President and Mrs. Wilson and several faculty members and their families.

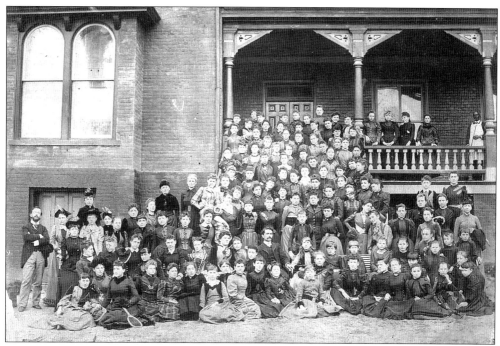

THE COLLEGE COMMUNITY. This *c.* 1890 photograph probably shows the entire student body of 174 and the faculty, with B.F. Wilson in the middle near the front. The younger students are from the preparatory department, which was abolished in 1898. Taken on the porch of West Main, the photograph shows that the original building lacked the large bay windows, which were added after the 1892 fire.

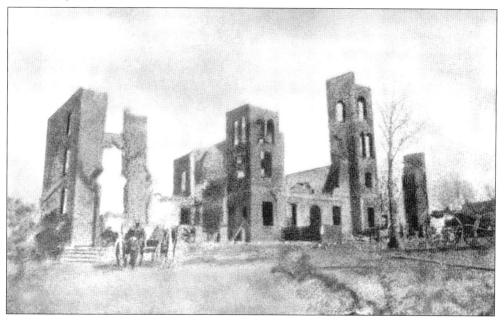

THE GREAT FIRE OF 1892. On January 2, 1892, shortly after 11:00 p.m., a fire began in the heating plant of Main Hall. Many of the students, who had just returned from the holiday, filled pitchers of water and tried in vain to contain the fire.

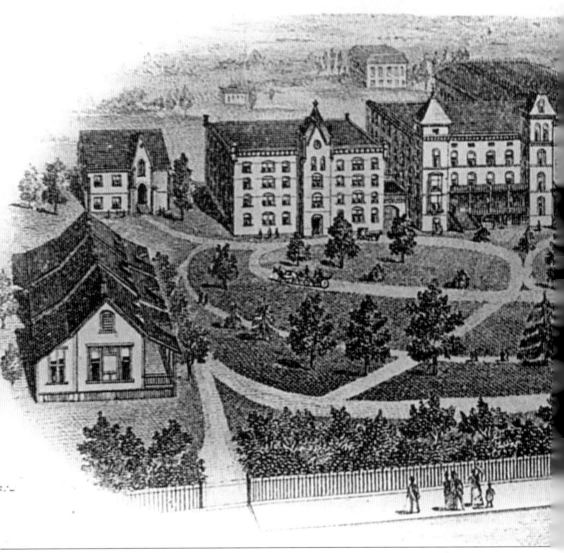

AFTER THE FIRE: THE NEW CAMPUS PLAN. Hearing the fire bells on the cold night of January 2, 1892, many citizens of the town rushed to the campus to help. As the fire spread, they dragged what furnishings they could out of the building. Only 4 of the music department's 15 pianos were rescued. The new $1500 pipe organ in the second-floor chapel was lost. President Wilson worked through the night, removing what he could and looking after the students, who lost most of their possessions. Neighbors took the freezing young women into their homes. That group of citizens who had founded the college so recently now came forward again to raise the funds that would be needed to rebuild. Prominent among this group were John B. Cleveland, John H. Montgomery, Wilbur E. Burnett, and W.S. Manning. Naturally, Edgar Converse was actively

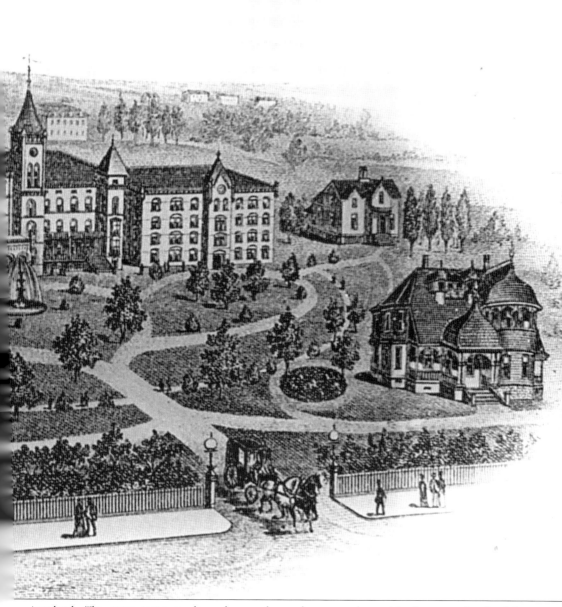

involved. The new campus plan, shown above, has several notable features. In the left foreground are three clapboard cottages, which were put up to house students. They are shown, in this sketch, out of proportion to their correct size. In the left background is St. John's Chapel. The sketch indicates the intention to erect identical annexes on both sides of Main Hall. The one on the left had already been built and survived the fire. The annex on the right was never constructed. Its site would soon be occupied by an auditorium. The Victorian-style house in the right foreground was built privately by President and Mrs Wilson as their new home. This property did not come into college ownership until the 1940s.

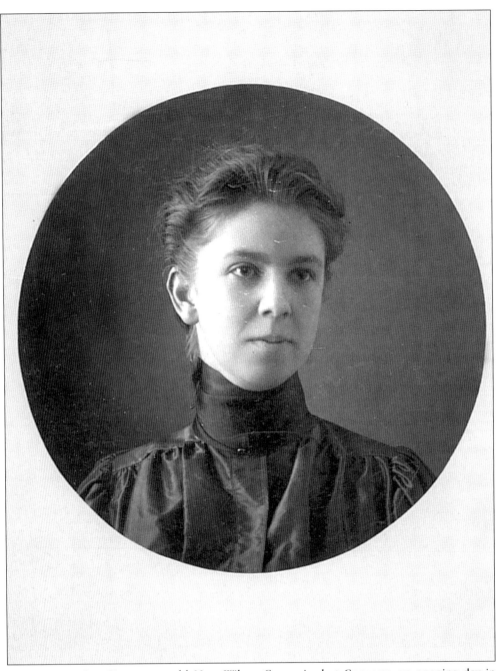

MARY WILSON GEE. Sixteen-year-old Mary Wilson Gee arrived at Converse on opening day in October 1890. She entered as a sophomore and was in the first graduating class in 1893. In 1896, she received an M.A. degree. She taught Latin at Converse from 1893 to 1963. For many summers, she led students on trips to Europe. She was dean of the College of Arts and Sciences from 1916 to 1941. Simultaneously, she was dean of students from 1916 to 1944. At one time, she also served as postmistress. When the college could not give her funds to buy a set of student mail boxes, she borrowed the money, bought the boxes, and charged rent. That set of mail boxes, with combination locks, is in the Converse Mail Room today.

THE COTTAGES. Three cottages were built after the fire to house students. Once the restoration of Main Hall was completed, they were used for faculty housing. For many years, one of the cottages was the home of Mary Wilson Gee and became known as the Dean's Cottage. Two of the cottages were moved to back campus in the early 1960s to clear space for Carmichael Hall.

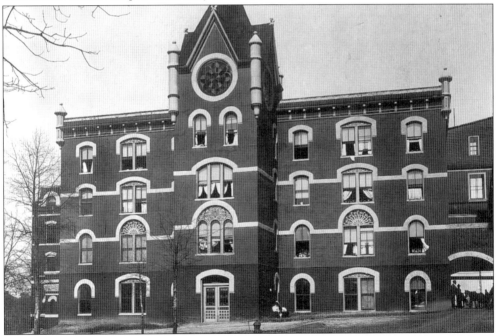

THE ANNEX. The second building on campus was completed in September 1891, in time for the college's second session. It contained several recitation rooms, two calisthenics rooms, literary society halls, and residence rooms. It survived the 1892 fire. After the death of retired President Robert Pell in 1941, the annex was renamed Pell Hall.

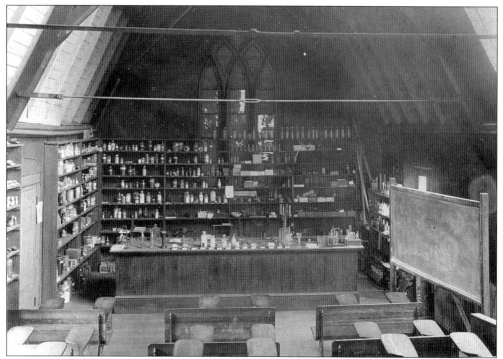

CHEMISTRY LABORATORY. St. John's Chapel served as a science building during the early years. From the beginning of the college, it was thought important that women be taught science. Physics and botany were required in the sophomore year; chemistry and zoology in the junior year; astronomy, geology, and mineralogy in the senior year.

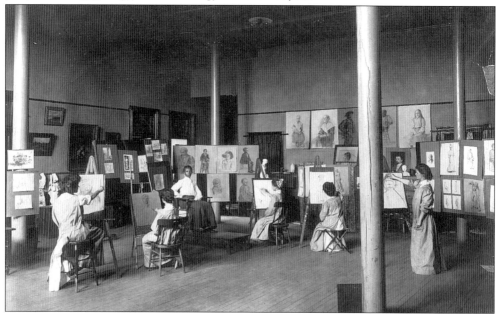

THE ART STUDIO. The art studio originally occupied the top floor of West Main, which had a mansard roof with skylights. Later it would be moved to the area on the second floor behind the chapel and above the dining room.

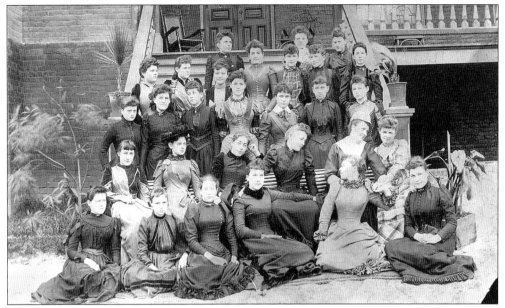

THE CARLISLE LITERARY SOCIETY. Named after Wofford College's president, James H. Carlisle, the Literary Society was founded in January 1891. The aim of the society was "to secure a high grade of literary work, essays, and poems, and quick, pointed thought in impromptu work and debating." A Philosophian Literary Society was also organized in the same year. They both met in the Annex. Although literary societies were clearly popular in this 1891 photograph, participation declined by the 1930s and both societies died out.

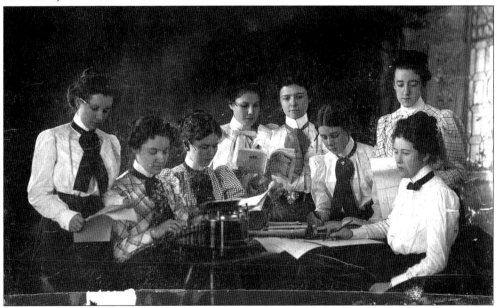

CONCEPT STAFF OF 1899. The Carlisle and Philosophian Literary Societies began the first literary magazine of the college. Founded in 1893, *Concept* published articles presented at the meetings of the societies. Shown from left to right are Mary Thompson Scott, Bessie Smith Briggs, Elizabeth League, Louise Gilland Scherfesse, Sallie Dean Heintish, Gertrude Gee Lesesne, Mary Huffman, and Elizabeth Payne Parsley.

THE LIGHTER SIDE. In addition to serious literary pursuits, students of the 1890s had a sense of humor as well as voluminous pleated skirts. Shown from left to right are Nell Elizabeth McGee, Eilleen Reed Mauldin, Blanche Salley, Marie Scheper, and Margaret Stewart.

THE BOWLING ALLEY. Lillian Kibler's *History* states that campus athletics were growing in popularity by the mid-1890s. In 1894, a bowling alley was constructed on the left side of the back campus. Built over a small stream, it resembled a covered bridge "with a portico in front and the alley proper extending behind it." Bowling became popular with both students and faculty.

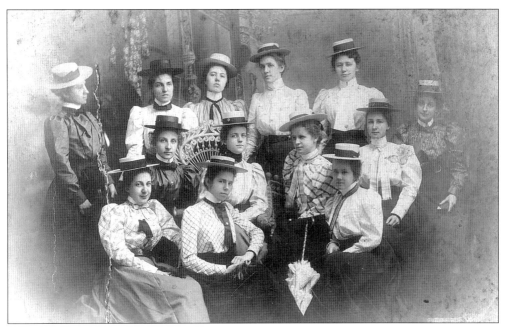

Phi Delta Sorority. In the 1890s a number of social clubs and sororities were formed. Some functioned as dance clubs, while others existed to establish friendships. Sororities were abolished by action of the faculty in the 1930s.

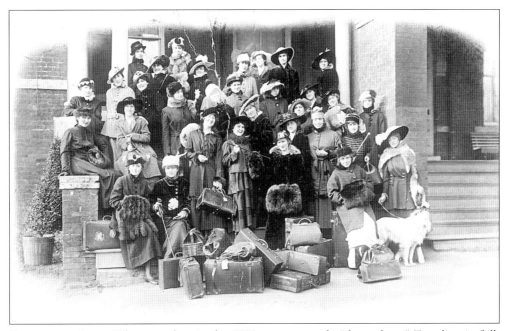

Traveling in Style. When traveling in the 1890s, most people "dressed up." Traveling in full-length skirts was difficult because of the unpaved, muddy streets around the train depot and the college.

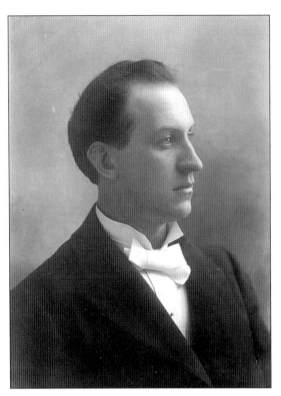

RICHARD HENRY PETERS. Peters, who was born in England, became director of the Music Department in the fall of 1893 and served in this capacity until 1904. He organized the Converse Choral Society and began the tradition of an annual spring music festival. The first May Festival was held in 1895 in the Main Hall Chapel, where a new $7,000 organ given by Edgar Converse to replace the instrument lost in the fire was installed. In 1898 the festival was renamed The South Atlantic States Music Festival. The festival continued to grow each year, with artists coming from New York, Chicago, and Europe.

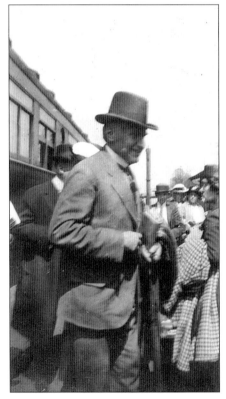

WALTER DAMROSCH. Damrosch was conductor of the New York Symphony Orchestra. This photograph was taken by Converse student Vera Keller Lawbough, Class of 1917, as Maestro Damrosch arrived at the Spartanburg Depot for the 1915 festival. Damrosch and the New York Symphony participated in the festivals for several years. Both the conductor and the orchestra members liked to sit on the Converse campus and talk with the students. In 1914, the festival was renamed the Spartanburg Music Festival. The Depression brought an end to the annual event in 1930.

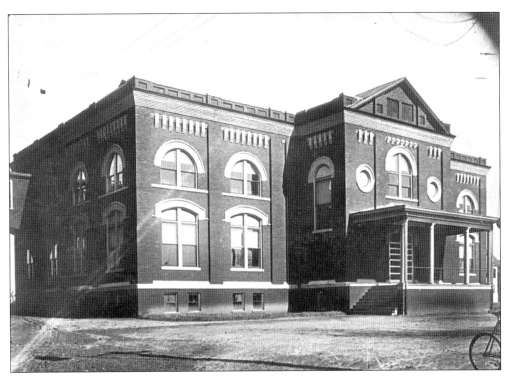

THE CONVERSE AUDITORIUM. The chapel in Main Hall soon became inadequate for the South Atlantic States Music Festival, and construction on the Auditorium began in 1898. The formal opening was in March 1899. The facade has been altered four times in the past 100 years. For many years the building served Spartanburg as a "municipal auditorium."

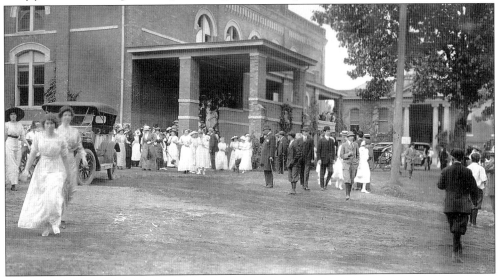

AUDITORIUM ADDITION. In 1908 the size of the Auditorium was expanded and a large number of practice rooms were added on the back to accommodate the growing needs of the Music Department. The facade was altered, including the addition of a porte-cochere. This picture dates from about 1913. (From the album of Sallie Rembert, Class of 1916; courtesy of Ann Richards McCall Crenshaw, Class of 1972.)

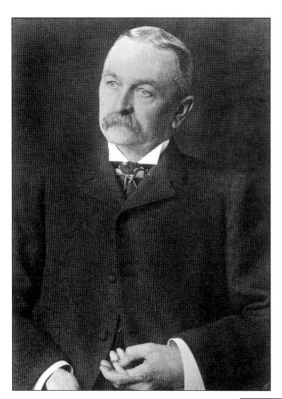

ALBERT H. TWICHELL. In 1941, the Converse Auditorium was renamed Twichell Auditorium. Albert Twichell was the younger brother of Helen Converse. In 1858, at the age of 18, he was given a job by his brother-in-law in the Bivingsville Cotton Factory. After four years in the Confederate army, he became associated with D.E. Converse & Company and later succeeded Edgar Converse as its president. Active in the cultural life of Spartanburg, he was organist at the First Presbyterian Church and first president of the Converse Choral Society and the May Festival of which he was a patron. He died in 1916.

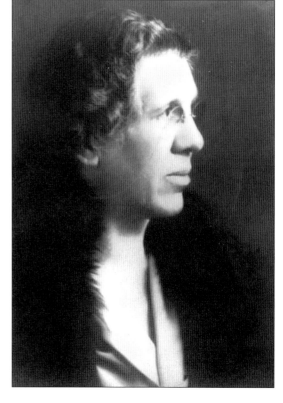

MARY HART LAW. One of the earliest students of music at Converse was Mary H. Law. In 1894, she earned a certificate in pianoforte and was persuaded by R.H. Peters to return as a piano teacher and to become the first to be awarded, in 1899, a B.Mus. degree at Converse. She was a member of the Music Department for 46 years, retiring in 1940. The Pre-College Department of the present School of Music developed out of the pedagogy classes taught by Mary Law.

BLONDELLE MALONE. After studying art and music at Converse from 1893 to 1896, Malone pursued further study. Her paintings of gardens show the influence of the Impressionists. A series of her garden paintings, which were a gift of the artist, hung in the lobby of Main Hall. In the 1980s, they were discovered neglected and in storage. When Twichell Auditorium reopened in 1989, the paintings were restored and hung in the auditorium lobby.

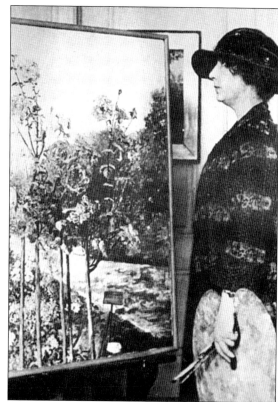

LOOKING TO THE FUTURE. The Class of 1904 met for its 50th reunion in 1954 and was inducted into the Golden Club. All alumnae who graduated 50 years ago or more become members of the Golden Club. Shown here, from left to right, are (front row) Leila May Gill, Celeste Marbut Clinkscales, Rhett Sheppard McColl, Daisy Singleton Barron, and Andrena Outzs Williams; (back row) Eoline Ligon Cunningham, Lily Robertson, Hattie Toney Boatwright, Gladys Eyrich, Moriat Gary McConnell.

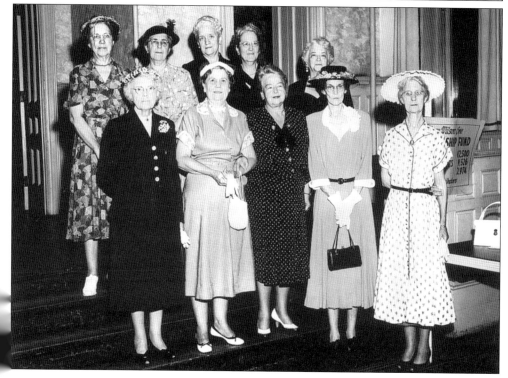

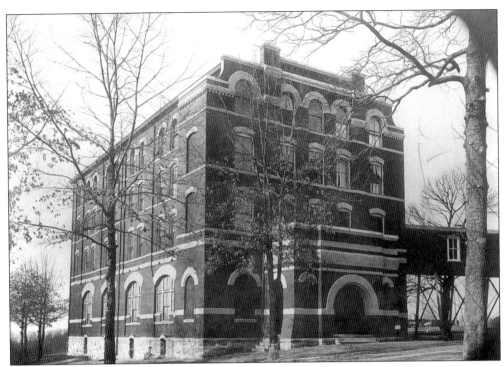

DEXTER GYMNASIUM AND DORMITORY. Built in six months in 1899, the new building housed both a gymnasium and a dormitory. The gymnasium, with tall windows, was on the ground level. A covered bridge joined the dormitory space with Main Hall. By using covered bridges, a student could walk from Dexter Hall into Twichell Auditorium without going outside. Although Mr. Converse preferred the name "Edgar," the new facility was named "Dexter" in his honor.

DEXTER GYMNASIUM. The gymnasium occupied what are now the first and second floors of the dormitory. Whether playing ball or dancing, students had to avoid the supporting columns that ran down the middle of the gym floor.

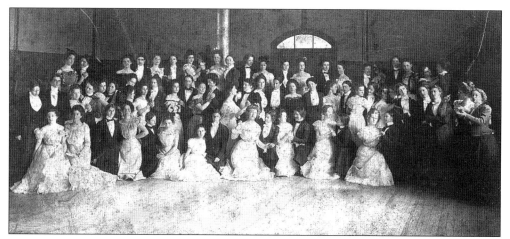

EARLY DANCE. The new gymnasium provided a large space for formal dances, from which males were strictly excluded. Half the students would serve as "male partners." They dressed in male attire, except for long black skirts. Once two Wofford students dressed as women and crashed a ball. Blondelle Malone was horror-stricken when she discovered that she was dancing with a male. The Converse students decided to ban the two Wallys from campus.

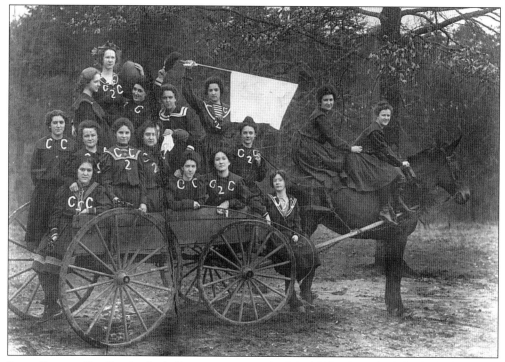

EARLY SPORTS. The first basketball team was organized in 1898, after which basketball grew in popularity. More popular still were baseball and tennis. In 1900, the Atalanta and Hyppolita Clubs were formed. Each consisted of a basketball team, a baseball team, and a tennis club. The two sports clubs competed for an annual cup and a $100 prize. The basketball team of 1900 (above) chose a rural setting for its photograph. (Photograph courtesy of the Spartanburg County Regional Museum of History.)

THE SECOND PRESIDENT. When Benjamin F. Wilson resigned in 1902, the Board of Trustees chose Dr. Robert P. Pell, president of the Presbyterian College for Women in Columbia, to serve as the college's second president. Like his predecessor, he was an ordained Presbyterian minister. He was a graduate of the University of North Carolina and taught there for several years as an instructor in English. As a young man, he served as principal of Cheraw Academy in Cheraw, South Carolina. Wilson's background in academics and administration benefited Converse during his presidency from 1902 to 1932. He set out to raise academic standards.

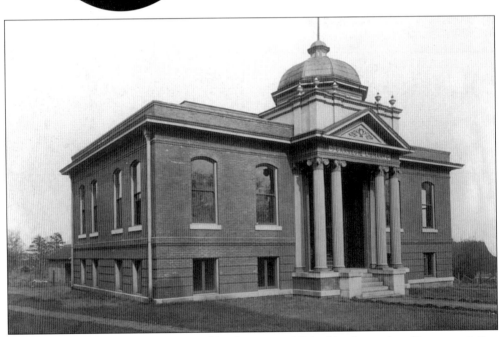

CARNEGIE LIBRARY. The first collection of books was established by the student literary societies, and the first library building was constructed on front campus in 1905 with funds donated by Andrew Carnegie. In 1905, the collection consisted of 5,000 volumes. This building served as the library until the opening of the new Gwathmey Library in 1951. Today, it houses administrative offices.

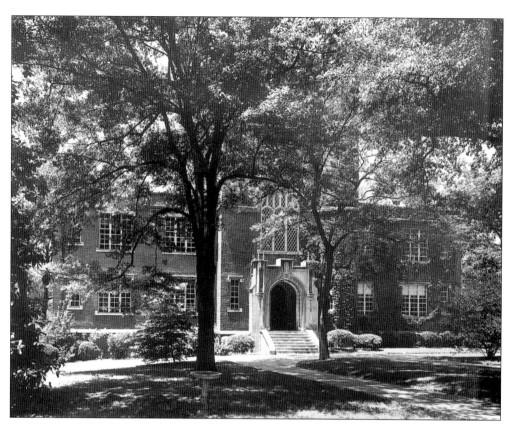

JUDD SCIENCE HALL. In 1915, St. John's Chapel was demolished and a new building was constructed on the same site with funds given by Eliza A. Judd. Mrs. Judd was an invalid who, from her home across Main Street from the college, enjoyed seeing the young students waiting for the trolley car. Judd Hall had an observatory in the top of the central tower. It ceased to be the science building when Kuhn Hall was opened in 1967. Judd Hall was demolished in 1981. A gazebo is on the site today.

LILLY STRICKLAND. Lily Strickland Anderson was a music student at Converse from 1901 to 1904, and then went on to study music in New York. She had a gift for melody and rhythm and published more that 200 musical compositions, including piano suites and a major composition for orchestra. Perhaps the best known of her works is the song "Mah Lindy Lou." In 1924, Converse awarded her an honorary Doctor of Music degree.

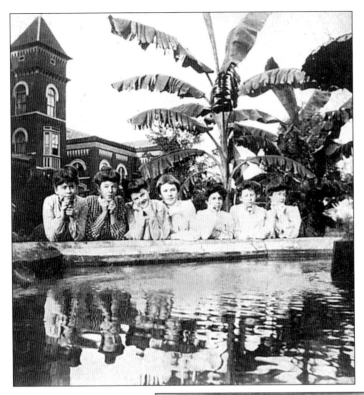

EARLY STUDENT LIFE. This scene, around the fountain on front campus, is from the fall of 1902. The students are, from left to right, Dot Bull, Genevieve Parkhill, Clelia Gray, Edith Smith, Cary Abercrombie, Minnie Dameron, and Maxie Sheppard. There were numerous banana trees on campus at this time. (Photograph from the album of Marion Sease Doom, Class of 1905.)

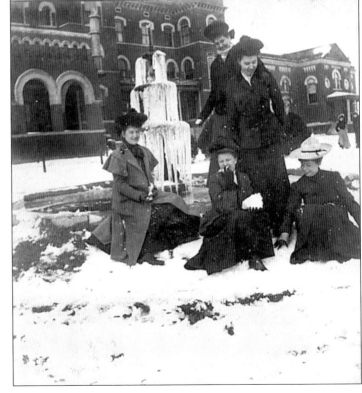

FOUNTAIN IN WINTER. This scene is from the winter of 1904 and shows the fountain that was once located in a small park at the eastern end of Morgan Square in downtown Spartanburg. When it was removed in the 1890s, it was purchased by a citizen and given to Converse. Later it would be moved to the rose garden on back campus. Visible on the left is the porte-cochere that was added to the entrance of Main Hall after the fire. The recently completed Converse Auditorium is on the right. (Photograph from the album of Marion Sease Doom, Class of 1905.)

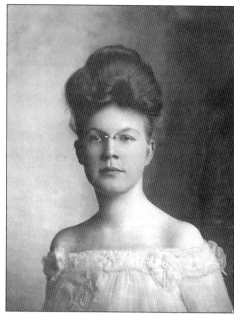

MARION SEASE DOOM AND ALICE BURNETT CLEVELAND. Marion Sease, left, is shown in a black gown and with a gavel as president of the Carlisle Literary Society. Alice Burnett (Class of 1905), right, was the daughter of Gertrude DuPré Burnett and Wilbur Emory Burnett. W.E. Burnett was one of the town leaders who met in 1889 to found a college for women. (Photographs from the album of Marion Sease Doom.)

YOUNG WOMEN'S CHRISTIAN ASSOCIATION. Organized in 1898, the Y.W.C.A. soon developed a strong influence on campus life. It met on Sunday evenings in the Main Hall Chapel. The group shown here is from 1913. (From the album of Sallie Rembert, Class of 1916; courtesy of Ann Richards McCall Crenshaw, Class of 1972.)

THE CROW'S NEST. This pavilion was a gift of the Class of 1914 and became the traditional site of the senior class-day program during the commencement events. After their last chapel, the senior class would proceed in cap and gown to the Crow's Nest and present a program for the student body. The pavilion was located approximately where the Gwathmey Wing of the Library sits today. This scene shows the Class of 1916.

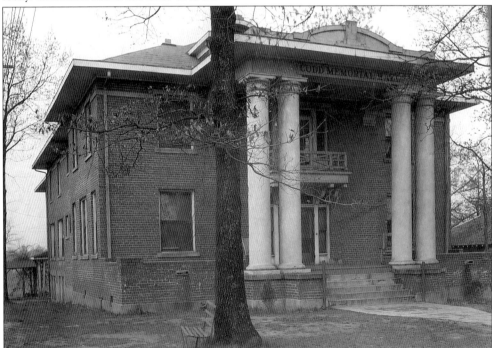

CUDD DORMITORY. The Gwyn School was built in 1914 on North Fairview Avenue by three Gwyn sisters to prepare students for admission to Converse College. In 1920, Converse College purchased the property, built an addition, and transformed the building into Cudd Dormitory, named in memory of Allene Cudd Cantrell, Class of 1912.

Two

PROGRESS AND DEPRESSION

1920s–1930s

When Converse College was founded, the course of study during the first two years resembled the curriculum of the last two years of high school today. This was made necessary by the fact that most public schools—at least in these parts—had only nine grades. By the 1920s, the academic situation had changed. Improvement in high schools and the strenuous efforts of President Robert Pell had raised academic standards and curricula levels. In 1912, Converse College was the first college in South Carolina to be admitted to membership in the Southern Association of Colleges and Secondary Schools. In 1923, Converse achieved the same distinction within the state by being admitted to membership in the American Association of University Women. In 1925, Converse was once again the first in the state to be accredited by the Association of American Universities.

Edward Gwathmey succeeded President Pell in 1933, in the midst of budget cuts and declining enrollments. By 1939, Converse was reviving and celebrated its golden anniversary.

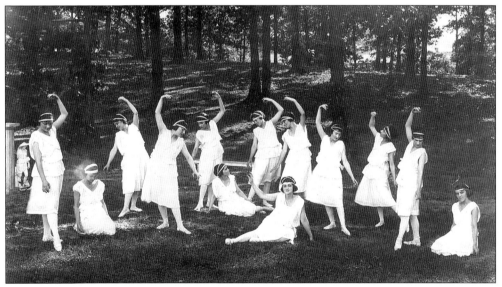

MAY DAY. Greek dances in the "Forest of Arden," the wooded area in the back of the campus, were a standard feature of May Day celebrations. Dancing in this scene are, from left to right, Sophia Wolf, Geraldine Hatcher, Alma Sally, Nancy Bomar, Mary Greer, Leslie Moss, Margaret Anderson, Pat Sheperd, Margaret Virginia Ervin, Mary O'Neal, Esther Cloud, Margaret Taylor, and Kitty Weston.

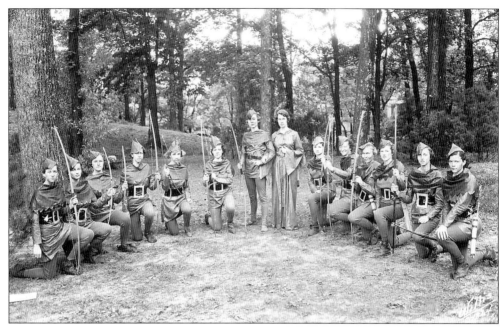

THE FOREST OF ARDEN. The first May Day at Converse took place on May 2, 1910. During the May Day shown in this photograph from the 1920s, the queen is appropriately escorted by Robin Hood and protected by his merry band. (Photograph by Alfred T. Willis.)

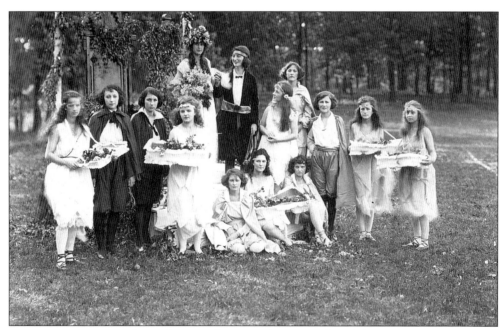

MAY DAY PERFORMERS. The performers shown in this scene, from left to right, are as follows: (standing front) Agnes DePass, Elizabeth Boykin, Mary Shipp, and Mary Louise Harrell; (seated front) Let Jackson, Mary Nelson, and Margaret Edens; (standing) Billy Brown, Margaret Irvin, Margaret Dowling, Ida Brabham, Margaret Minge, Adaline Bostic, and Louise Stevens. (From the scrapbook of Henrietta Fennell Lesesne, Class of 1924.)

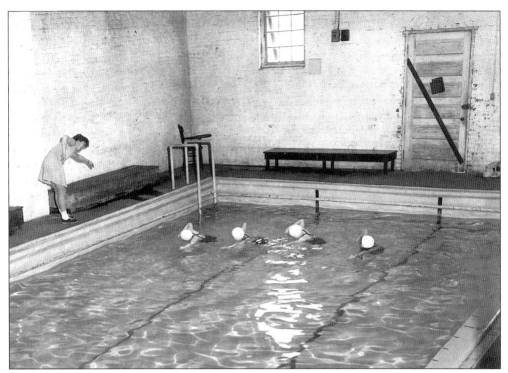

DEXTER SWIMMING POOL. In 1915, a swimming pool was added to the rear of the Dexter Gymnasium. It was located where the counselor's apartment and the lounge are today.

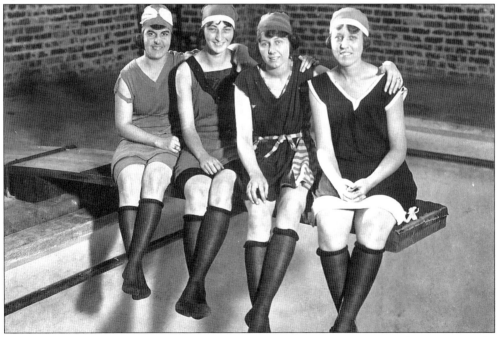

SWIMMING COMPETITION. After the pool was built, swimming grew in popularity among the students. Interest was heightened by an annual championship competition held by the Athletic Association. The winning class received a silver loving cup.

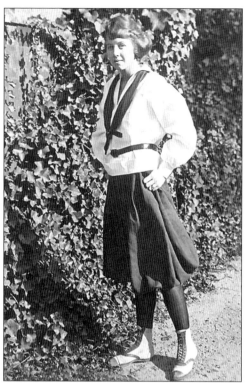

ATHLETIC ATTIRE. Whatever the sport, the bloomer (named for Amelia Bloomer) was acceptable attire. The variety of sports played at Converse was growing. *Concept*, in the spring of 1919, reported "Athletics have had a foremost place in our activities for the past few weeks. We are carrying seven sports: Basket-ball, baseball, hockey, archery, track, swimming and tennis."

BASKETBALL. Basketball continued to be one of the most popular sports in the 1920s. A "Block C" could be earned by students who excelled in sports. The Athletic Association instituted a point system. By 1926, a student had to earn 1,000 points to earn a "Block C."

SWIMMING. Part of the money necessary to build the Dexter swimming pool was raised by the students. They sold sandwiches and fudge and sought donations from businesses in Spartanburg and from alumnae. The new pool was used not only for class competitions but also for individual, recreational swimming. Faith Courtney (Burwell) poses at the pool entrance in this photograph. (From the scrapbook of Henrietta Fennell Lesesne, Class of 1924.)

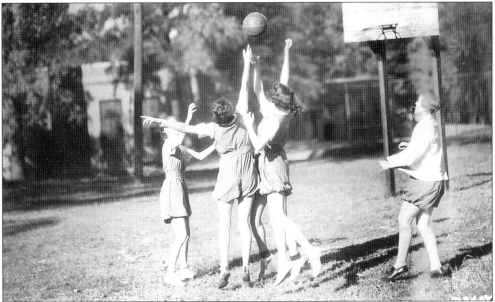

BACK-CAMPUS BASKETBALL. In addition to the basketball court in Dexter Gymnasium, there was a hoop on back campus for the enjoyment of small groups. Basketball soon competed for popularity with other sports. An archery contest was held for the first time in 1926. Volleyball became a class sport for the first time in 1931. The power plant, seen in the background, was built in 1925.

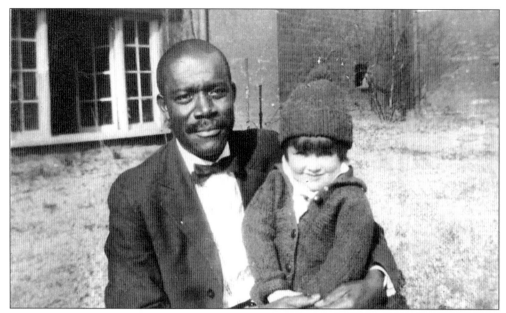

THE CHESTERFIELD OF THE CAMPUS. Charlie Gregory was a college employee for 46 years. He was described as "a polite, pleasant and indispensable general utility man." Because of his dignity and dapper appearance, the students dubbed him "the Chesterfield of the campus." (From the photograph album of May Dryer, Class of 1919.)

HAZEL ABBOT. Miss Abbott was a faculty member from 1927 to 1956. A native of North Dakota, she held an M.A. in English from Columbia University. Lillian Kibler described her as "a young woman of rare intellectuality, artistry, and energy, with uncompromising standards in her profession."

LITTLE CHAPEL PLAYERS. In 1927, Miss Abbott organized the Little Chapel Players, which changed its name the next year to the Palmetto Players. The purpose of the organization was "to educate actors and audience to an appreciation of the best in drama." Shown in this view are Harriet Anderson, Hazel Abbott, Marjorie Foster, and Marion Heins from the early 1940s.

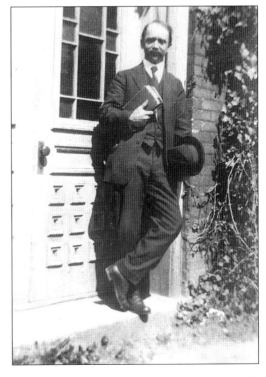

JOSEPH A. TILLINGHAST. "Tilly" was professor of history and social and economic science from 1902 until his death in 1944. He was the first chair of the History Department, when it was created in the 1920s. A Phi Beta Kappa graduate of Davidson College, he did graduate study at Cornell University. Known as the most popular teacher on the campus, he was a kind and gentle man, always anxious to see the other person's point of view. When faculty salaries were cut during the Depression, Professor Tillinghast wrote to the Board, "the Board may rest perfectly assured that it will make not a particle of difference in my attitude, spirit or work My concern is that the institution into which I have put all the prime of my life shall survive."

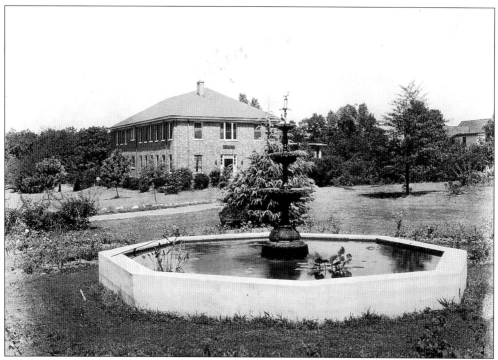

ANDREWS DORMITORY. Isaac Andrews, who was born in the Irish city of Belfast, was a local businessman. He contributed funds to build a dormitory in honor of his wife. In January 1927, Esther Thompson Andrews Hall was opened. At the time it stood almost alone on back campus. By this time, the fountain had been moved from the front campus to its present location.

NEW FACADE. In 1969, Andrews Hall was renovated on the interior, and a new facade was added to what had been the side of the dormitory. The cost of the changes was contributed by Florence Andrews Helmus in memory of her sister, Mary Andrews Stables.

GEORGE B. CLINKSCALES. "Clink" had a Ph.D. from Johns Hopkins University and was professor of mathematics at Converse from 1915 to 1952. Lillian Kibler described him as "one of the most individualistic personalities in the history of Converse Brilliant and original, he was the idol of his majors and the despair of freshmen." Faculty families were very much a part of the life of the college in these decades. Professor Clinkscales was photographed with his daughter, Nell, a future member of the Class of 1937.

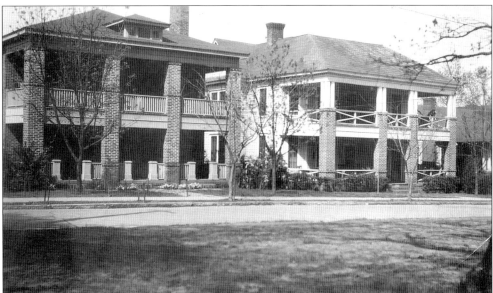

CLINKSCALES DORMITORY. Doing much of the work himself, Prof. George Clinkscales constructed two apartment buildings on North Fairview Avenue. His family occupied the ground floor of one building and rented out the other apartments. After the death of Professor Clinkscales, Converse bought the buildings and used them as dormitories. Occupying the site of the current parking area behind Andrews Hall, they were demolished about 1990.

JULIA PETERKIN. Julia Mood Peterkin earned two degrees at Converse: the A.B. in 1897 and the A.M. in 1898. While a student she was president of the Cycling Club and would serve as president of the Alumnae Association from 1925 to 1928. In the latter year, her book *Scarlet Sister Mary* won the Pulitzer Prize for the best American novel of the year.

ADOLPHE VERMONT. Born in Belgium, Dr. Vermont was a brilliant linguist who helped shape the character of the young women whom he taught. He was professor of romance languages at Converse from 1918 to 1949. In the community, he was a popular speaker.

DEAR MOLLY MIX. The first student newspaper, *The Parley Voo*, appeared weekly from 1924 to 1948. One of the most popular features was an advice column written by "Molly Mix." A new Molly Mix was chosen every year. Her identity was closely guarded and revealed only in the last issue of the year. A student once wrote, "The other day the boy whom I love saw my mother and fell in love with her. I don't mind that but if he marries my mother, he will boss me around. What shall I do?" Molly replied, "Double cross him. Marry his father and cut off his allowance."

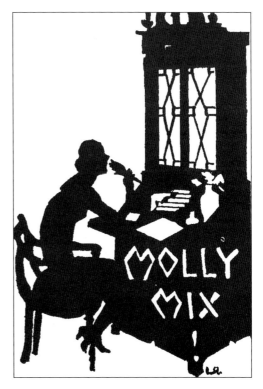

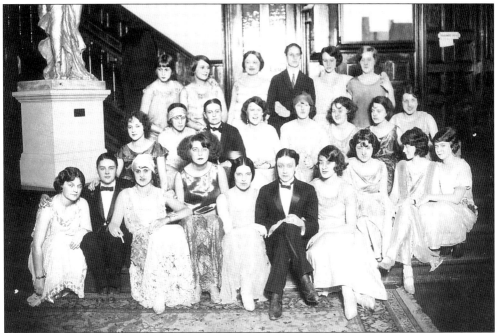

NO MALES ALLOWED. At campus dances in the 1920s, men were still not allowed; students still posed as male partners. The changing times did bring one innovation: the male partners could now wear trousers instead of black skirts. One of the senior superlatives published in the yearbook each year was a picture of the "Best Male Partner."

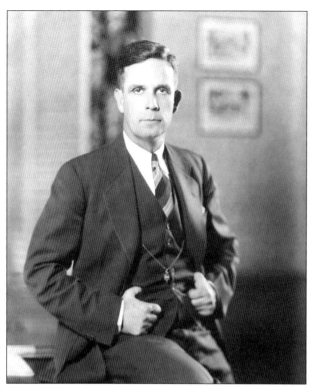

EDWARD MOSELEY GWATHMEY.
Unlike his predecessors, Converse's third president (1933–1955) came from an academic background rather than from the Presbyterian ministry. He had earned a Ph.D. in English from the University of Virginia. A Virginia gentleman with a fondness for gospel music, Dr. Gwathmey not only wanted to give the college a new look, he liberalized social rules and modernized the curriculum to better prepare young women for the modern world.

MILDRED BATES GWATHMEY. Mildred Gwathmey played an active role in the life of Converse College and its students. She was an attractive woman of considerable refinement, who assisted her husband in implementing campus improvements.

THE PRESIDENT'S HOME. This Victorian home was built by Prof. Richard Henry Peters in the 1890s on North Fairview Avenue. When he left in 1904, it was acquired by Converse for a president's home. The Gwathmeys were the last to occupy the residence. Because of their long tenure, it became known as "Gwathmey House." It was taken down in the mid-1960s.

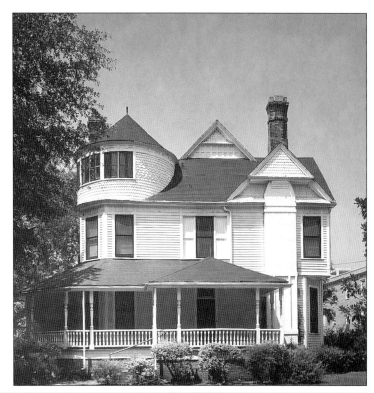

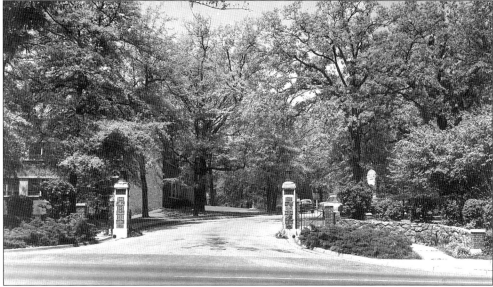

THE PELL GATES. Edward Gwathmey embarked upon a project to beautify the campus, including new gates at the main entrance. After his inauguration in May 1933, those present proceeded to the new Gates which were then dedicated to Robert Pell. The Pell Gates were west of where the main entrance is today and were not opposite Mills Avenue. The entrance road, as seen above, ran right in front of the Gwathmey Library (added in 1951). When the present entrance was constructed in 1966–1967, the Pell Gates were removed but traces of their foundations are still visible on front campus today.

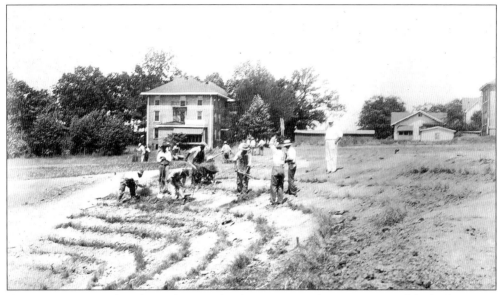

THE AMPHITHEATER. Edward Gwathmey's plan for improving the appearance of the back campus was aided in hard financial times by a relief program of the federal government. Assistance was obtained from the Reconstruction Finance Corporation in building an amphitheater in the Forest of Arden. Following the plan of alumna Helen Hodge, a landscape architect, 200 unemployed workmen created a series of terraces in 1933. Cudd Hall is in the background, before the addition of porches on its campus end.

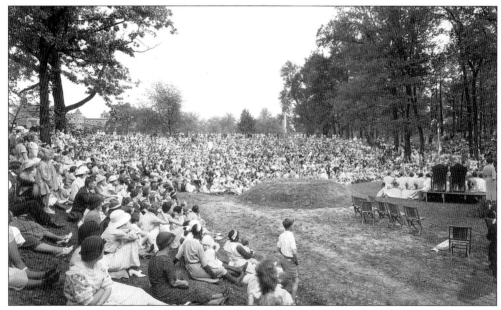

MAY DAY. With a seating capacity of 5000, the new amphitheater accommodated large crowds for May Day festivities and other theatrical events. May Day ceremonies attracted an average audience of 3000. The Palmetto Players often put on a play. The Athletic Association charged admission for the many persons from the community who attended.

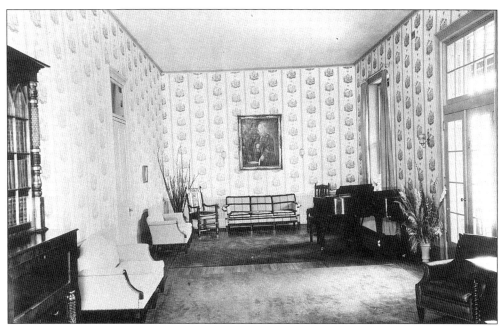

STACKHOUSE PARLOR. As a part of interior improvements, a new parlor was created in Wilson Hall out of two rooms that had been occupied by the president's office. Mildred Gwathmey played an active role in campus improvements. Partially financed by a contribution from T.B. Stackhouse, the parlor was dedicated to his daughter, Sadie Stackhouse Hawkins, Class of 1906.

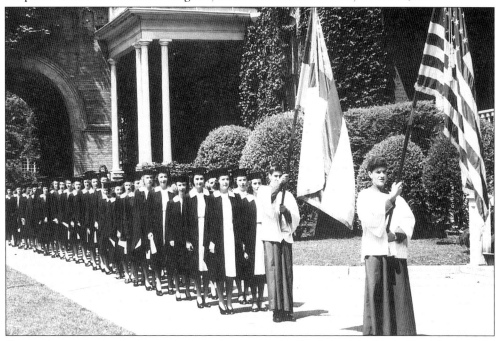

SENIOR CONVOCATION. At the beginning of each new academic year in September, there was a Senior Convocation in the Converse Auditorium to launch the seniors into their final year. Adorned in cap and gown, the seniors marched in a dignified procession from Wilson Hall to the Auditorium.

THE CROW'S NEST. The Crow's Nest on front campus continued to be a popular site for photographing student organizations. The group in this scene is not identified.

FRESHMAN-JUNIOR WEDDING. One of the strong traditions at Converse has been the sister-class relationship. The bond between the freshmen and juniors began in October of each year, when a "wedding" took place between the two classes. One year the bride from the freshman class was "Miss I.B. Green," and the groom from the junior class was "Mr. U.R. Right." The ceremony was discontinued in 1945 and was replaced by a less expensive ceremony at which each junior presented her little sister with a silver bracelet bearing the Converse seal.

PROPER ATTIRE. These warmly dressed students were also properly dressed. Skirts were still required almost everywhere on campus except in the dormitories. Other social rules were being liberalized, however. In 1933, the ban on males at campus dances was finally lifted. In the same year, the prohibition on smoking by students on campus was abolished. Students could now smoke in their rooms, in the lobby on Wilson Hall's second floor, on back campus, and in the campus tea room.

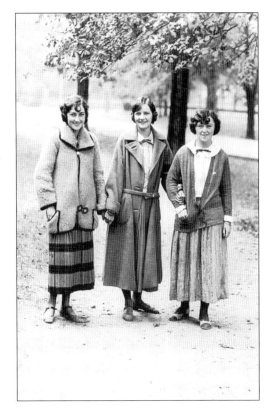

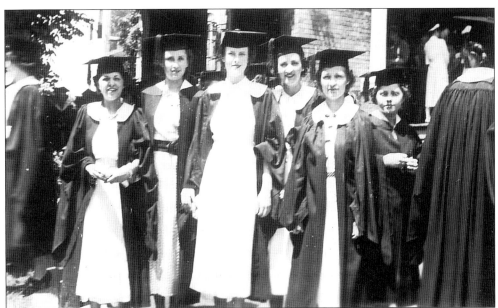

THE CLASS OF 1937. Posing after their graduation in 1937 are, from left to right, Zula Lee Bradford, Ouida Fort, Ruby Loflin, Mary Hipp Willson, Helen Miller, and Emily Ball. Proper graduation attire was academic gowns worn open over white dresses. (Photograph from the scrapbook of Lida Lorenz.)

CLASS REUNION. The Class of 1938 posed for its 10th Reunion in the English Room, located in Wilson Hall where the Alumnae Office is today. The Converse Alumnae Association was organized in 1894 and has created a close bond between graduates.

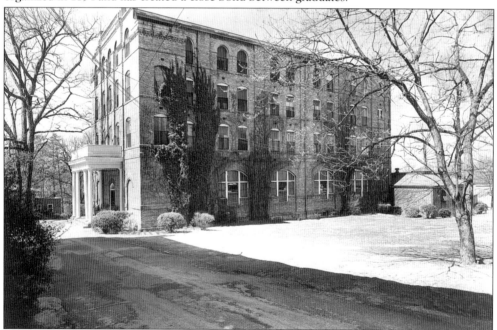

DEXTER HALL. The face of Dexter has changed several times since its completion in six months in 1899. The original entrance porch was replaced by one of neo-classical design to suit the changing tastes of the early 20th century. The swimming pool addition can be seen at the rear.

Three
WAR AND AFFLUENCE
1940s–1950s

During World War II, Converse students made their contribution to the war effort. They helped area farmers harvest their cotton crop and drilled twice a week on back campus. When Wofford College was taken over for use as a training center, Converse temporarily became coeducational. Wofford students attended classes as day students in 1943 and 1944.

In 1941, Mary Wilson Gee, who had been dean since 1916, retired from that position and was replaced by Elford C. Morgan. Enrollments, which had declined in the 1930s, rose significantly in the 1940s. At the end of the war, Converse discarded some old traditions and revised degree requirements to reflect contemporary demands.

After the retirement of Edward Gwathmey in 1955, Dean Morgan served as acting president until Oliver C. Carmichael assumed the duties of Converse's fourth president in 1956.

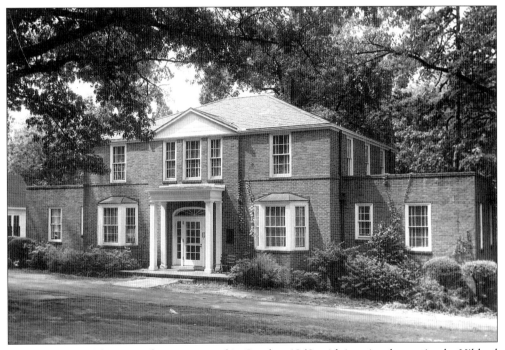

EZELL INFIRMARY. The new infirmary opened in October 1940, with interior decoration by Mildred Gwathmey. It was the first new building on campus since the construction of Andrews Hall in 1927. Samuel B. Ezell, for whom the infirmary was named, was chair of the Board of Trustees from 1921 to 1926, and a bequest left by him made the facility possible. During the construction of Carmichael and Kuhn Halls in the 1960s, Ezell was moved to the right several yards and elevated. Its original entrance was flush with the ground.

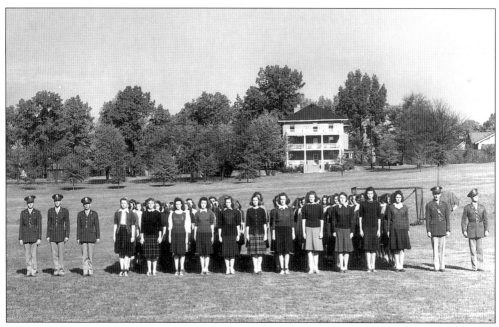

CONVERSE AUXILIARY CORPS. Under the instruction of officers from Camp Croft, volunteers learned the fundamentals of military drill and followed a rigid program of physical fitness. By this time, porches had been added to the campus end of Cudd Hall.

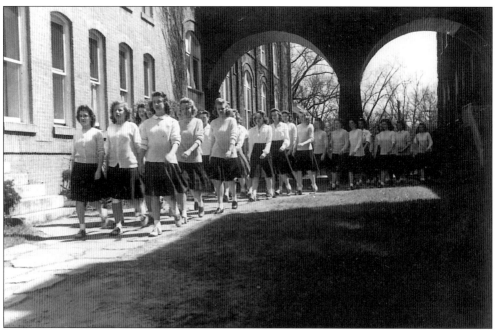

MARCHING UNDER THE ARCHES. The Auxiliary Corps marches under the arches connecting Wilson Hall and Twichell Auditorium. An enclosed bridge connected the Twichell balcony with Wilson Hall's second floor. If there was rain during convocations or graduations, the academic procession used this bridge. After it became unsafe, the bridge was removed during the Auditorium alterations in 1987.

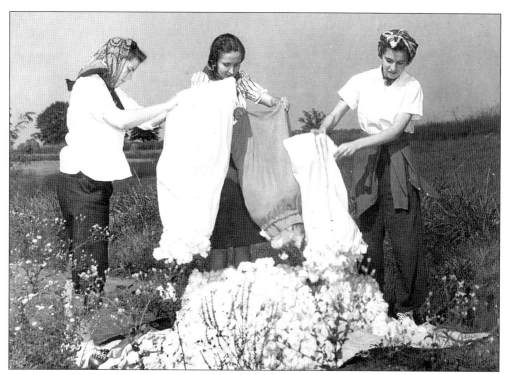

COTTON PICKING. Because of the labor shortage during the war, Spartanburg County's cotton crop, worth $5 million, stood in danger of being lost. Converse students regularly loaded onto buses to be taken out to the fields. During one afternoon, 80 students picked 1,400 pounds of cotton. (Photograph by Randolph Bradford.)

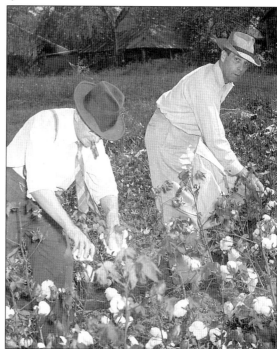

PRESIDENT GWATHMEY. Faculty and administrators joined the students in the cotton fields. Edward Gwathmey, right, is joined in this picture by Spartanburg businessman Charles P. Hammond. (Photograph by Randolph Bradford.)

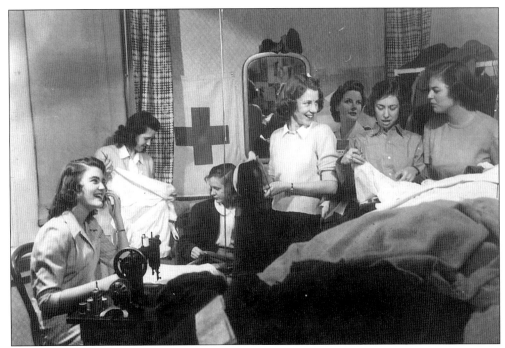

RED CROSS VOLUNTEERS. A Red Cross sewing room was set up in a basement room of Judd Science Hall. There student volunteers could make bandages for the military.

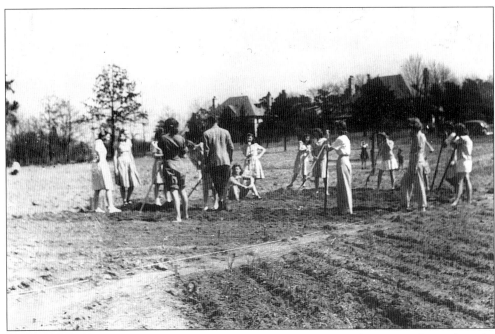

VICTORY GARDEN. To help make up for the food shortage caused by the war, students planted a Victory Garden. Many people planted such gardens in their yards.

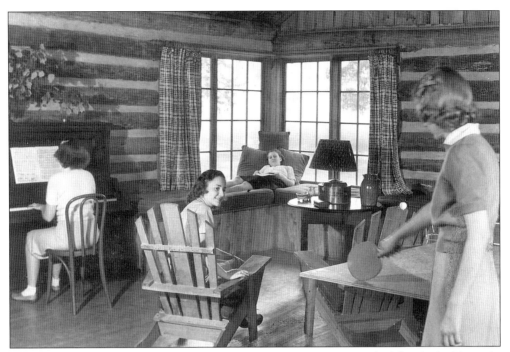

THE CABIN. The Y.W.C.A., supported by other campus organizations, asked for the building of a log cabin on campus as a place for recreation. After the students raised most of the money, the project was completed in 1938 in the Forest of Arden. Serving somewhat as a student lounge, the cabin was open to all students during the day and to groups of no-less-than five couples in the evening by reservation.

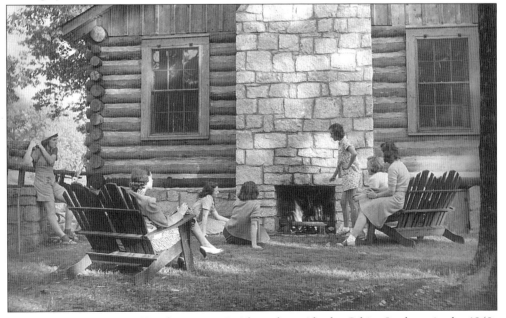

TOASTING MARSHMALLOWS. Fireplaces were inside and outside the Cabin. Students in the 1940s spent much of their time on campus. They had no cars, and rules still restricted campus departures. Toasting marshmallows thus became a favorite afternoon activity.

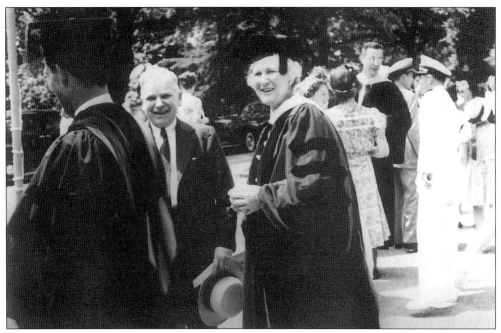

MAUDE BUSCH BYRNES. At graduation on May 31, 1943, Maude Byrnes (Class of 1902) was awarded an honorary degree. At the time her husband, James F. Byrnes, was director of the Office of War Mobilization in Washington and later served as secretary of state and governor of South Carolina. While a student, Maude Byrnes studied music and played left field on the baseball team.

ROANOKE GROUP. In the 1940s, Converse was very much a regional college, attracting students from all over the southeast. These students, identified from left to right, were all from Roanoke, Virginia: (front row) Rebecca Stone, Ruth Johnson, Rosemary Hark, and Edith Hubbard; (second row) Janice Mayhew, Virginia Young, and Leila Carson; (third row) Bettie Jenkins, Frances Minter, Ida Penn Shackleford, and Elizabeth Harp; (top row) Alice Clare King and Liza Lunsford.

READY TO TRAVEL. By the 1940s, travel was much less formal than 50 years earlier (see page 21). Shirtwaist dresses and saddle oxfords with socks or sandals were acceptable. Notice the hat boxes on the left.

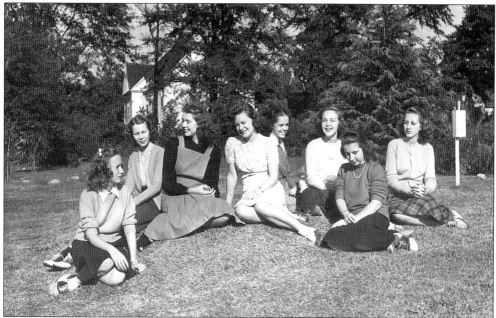

WILD THYME. In 1920, students interested in promoting creative writing organized Wild Thyme. Their poetry and stories often appeared in the *Concept*. Wild Thyme survived the demise of the literary societies in the 1930s and continued into the 1940s. Shown from left to right are Hope Rogers, Ruth Rowlett, Augusta Beckman, Mary Shaw Love, Josephine McWhorter, Mary Lib Pratt, Bippy Hunter, and Elizabeth Harris.

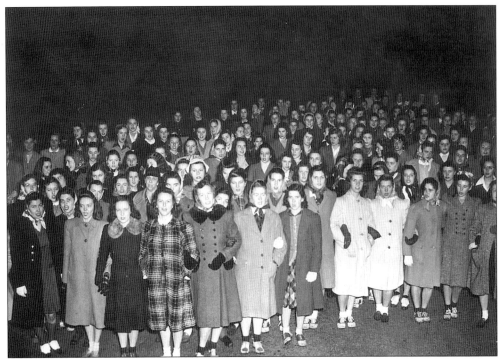

CHRISTMAS CAROLING, 1941. A campus tradition for several decades was Christmas caroling, accompanied by Miss Gee. (Photograph by West the Photographer.)

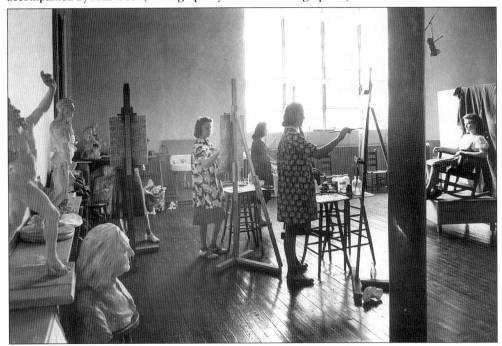

THE ART STUDIO. Originally in West Wilson, the art studio was now located on the second floor of Wilson Hall, in the space behind the Little Chapel (Abbott Theatre). In 1934, Converse became the first college in South Carolina to establish an art major.

Music Festival, 1942. With the Depression coming to an end, the annual Spartanburg Music Festival was revived in 1939. The center piece of the festival in 1942 was the world premier of *A Tree On The Plains*, a folk opera by Ernst Bacon and Paul Horgan. Ernst Bacon was dean of the Converse School of Music from 1938 to 1945. Ranked as one of the leading young composers in the United States, Dean Bacon won the Pulitzer Prize for music in 1932. One reviewer of the new opera declared that the music contained "elements of greatness." A leading role in the production was taken by Converse music professor, Radiana Pazmor.

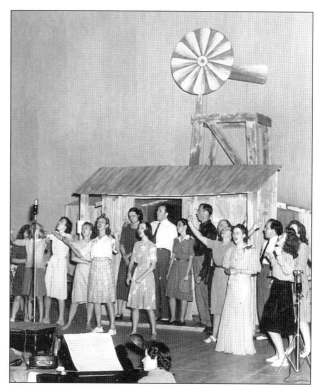

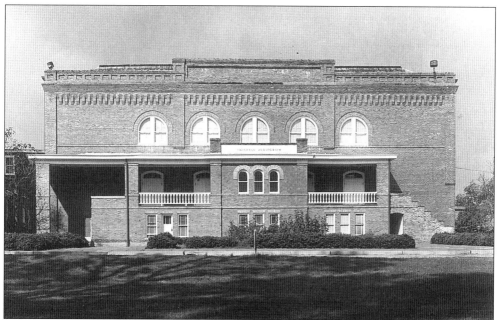

Twichell Auditorium. In 1941, the Converse Auditorium was renamed Twichell Auditorium in honor of Albert H. Twichell, the first president of the Spartanburg Music Festival and brother of Helen Twichell Converse. In 1957, the porte-cochere, which had been added on the left of the facade, was removed. The room with three arched windows on the second level, in the middle of the porches, was a box office. (Photograph by Terrell Photography.)

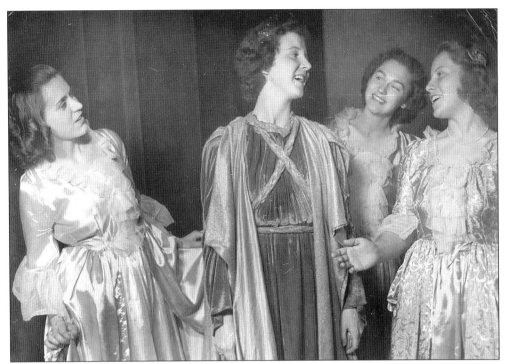

DIDO AND AENEAS. For the 1940 festival, the School of Music staged a production of Henry Purcell's *Dido and Aeneas*. Students made up the majority of the cast. Pictured from left to right are Mary Elizabeth Cates, Ruth Ives (a teaching fellow in voice), Adeline Godfrey, and Rose Goodman.

MAY DAY DANCERS, 1942. By the 1940s, May Day performers were more likely to be dressed as mountain cloggers than as Grecian dancers. Pictured from left to right are Frances Green, Sara Harris, Sue Robbins, Doris Hatchett, Frances Harvey, Mary Ellen Jennings, Dorothy Foster, Lou Carlisle, Imogene Taylor, and Miriam White. (Photograph by Charles N. Gignilliat Jr.)

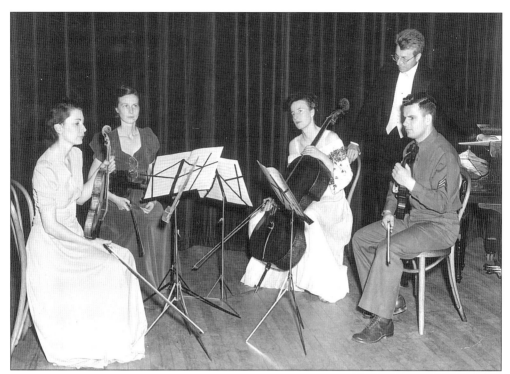

CHAMBER MUSIC, 1942. At the annual spring festival, chamber music delighted audiences. Shown in 1942, from left to right, are Claire Harper (concertmaster and instructor in violin), Peggy Thomson Gignilliat (Class of 1934), Analee Culp, Edwin Gerschefski (professor of piano), and Sgt. Gilbert Halasz from Camp Croft.

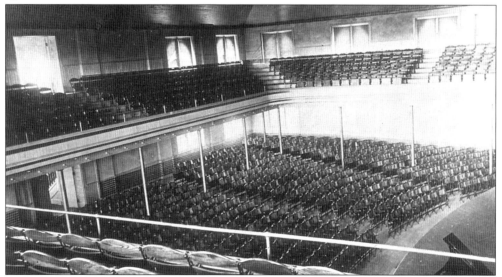

TWICHELL INTERIOR. Much of the original interior of Twichell Auditorium was made of wood—including the ceiling and the seats. The acoustics were exceptional. Leopold Stokowski stated that he heard portions of a score he had never been able to hear in any other auditorium. The posts supporting the balcony obstructed the view from nearby seats. During renovations in 1957, new seats were installed on the ground level, and a new stage and orchestra pit were built.

LOUISA CARLISLE. For 37 years, from 1927 to 1964, Louisa Bobo Carlisle (Class of 1915) was librarian at Converse. Her degree in library science was from Emory University. A native of Spartanburg, she had a passion for books and for local history. She was involved in establishing the Quaint Side Tea Room, but her greatest accomplishment was overseeing the construction of the new Gwathmey Library. Much of the strength of the present collection is a legacy of her varied intellectual interests. (Photograph courtesy of Walton Carlisle Beeson.)

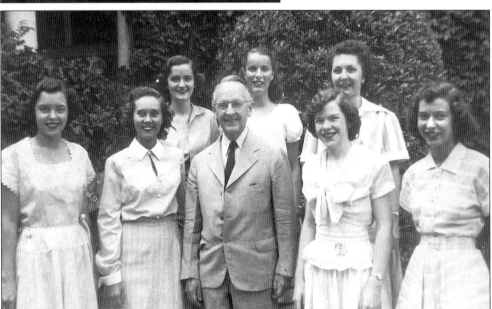

CLASS OF 1949. Considering the white dresses, this picture was possibly taken at graduation. Pictured from left to right are (front row) Jean Elizabeth Garrison, Lila Mae Gaines, Dr. George F. Taylor, Caroline Hunter Fant, and Harriette Wilmer Smythe; (back row) Cynthia Louise Townsend, Avery McLean Sylvester, and Carolyn Grace Wilcox. George F. Taylor was professor of Philosophy and Religion from 1935 to 1949. (Photograph courtesy of Martha Paxton Beale, Class of 1949 and member of the Converse One Hundred.)

Elizabeth Bearden. While a member of the Class of 1921, Elizabeth Bearden established a record for herself as a creative writer. In 1940, she returned to Converse as a member of the English faculty, a position she held until her retirement in 1961. As a teacher, she instilled her love of writing in her students. Three times a year, she issued a mimeographed collection of freshman compositions entitled "We, the Freshmen."

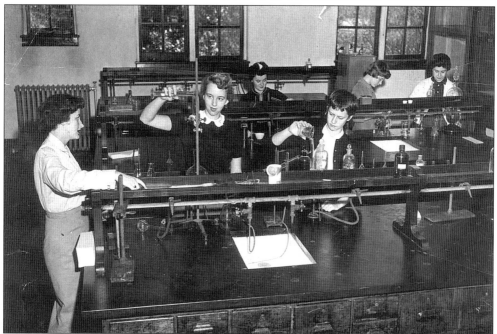

Judd Science Lab. By the 1940s, the stringent science requirements of the 1890s had been reduced. For graduation, students had to take two sciences and two math courses. In the 1950s, the requirement was similar but allowed more choice between science and math. The two areas were joined together, and students were required to chose four courses from science and math.

ALINE SAUNDERS WEST. Mrs. West taught science at Converse for 37 years from 1930 to 1967. Although her main area was chemistry, she sometimes taught physics as well. A graduate of North Carolina College for Women, she earned an M.A. degree from Columbia University. The record shows that, as a member of the faculty, she bore more than her share of committee work.

CARNEGIE LIBRARY. By 1945, the Carnegie Library was 40 years old and lacked adequate stack space and study areas to meet the needs of the college. Plans began to be made for the construction of a new library.

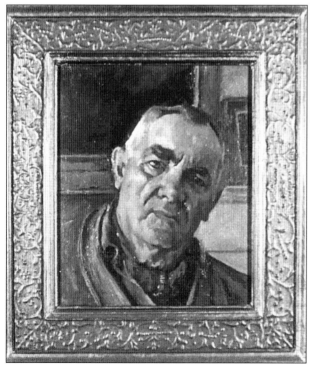

AUGUST COOK. Shown here in a self-portrait, August Cook studied at the Pennsylvania Academy of Fine Arts and then taught art at Converse from 1924 to l966. He worked in many forms, including pottery, oil, watercolor, egg tempera, and sculpture. Cook particularly excelled in wood engraving. In fact, he carved the frame for his self-portrait. He designed lavish sets for Palmetto Players' productions and, after men were permitted to play male roles in 1936, acted in many productions. His wife, Irma Cook, was an artist of significance. The two together significantly influenced art in Spartanburg in the 20th century.

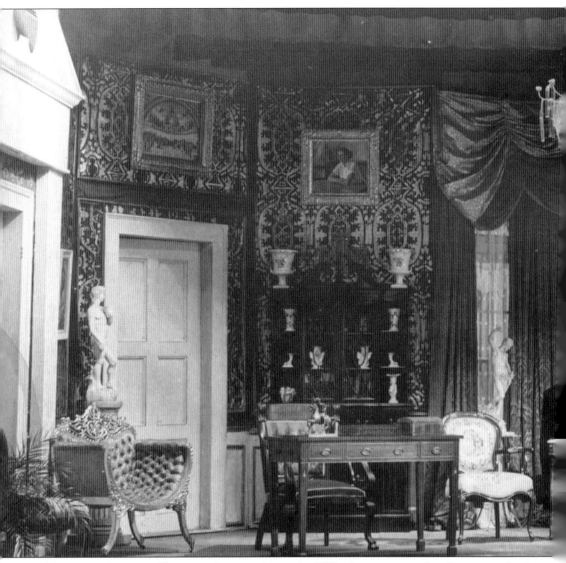

THEATER AT CONVERSE. Theater at Converse began in 1898, when a group of students organized a Dramatics Club, which was sometimes known as the Mummers. They mounted productions, often in the Forest of Arden, without the aid of formal courses in drama. Their activity was regarded as extracurricular. After Hazel Abbott joined the faculty in 1927, dramatic productions became an art form in their own right. The elaborate set shown above was designed by August

Cook for the Palmetto Players' 1942 production of George Kaufman and Edna Ferber's play, "The Land Is Bright." The production shows the result of the collaboration between an extraordinary director and a talented designer: Hazel Abbott and August Cook. During the 1941–1942 academic year, the Palmetto Players staged 20 productions.

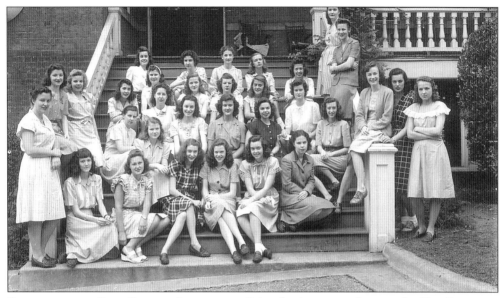

GRANDDAUGHTERS CLUB. Converse became a tradition for the women in many families. It was not unusual for a student to be third generation. The Granddaughters Club brings together the students with this common heritage. The 1947 members assembled on the steps of West Wilson.

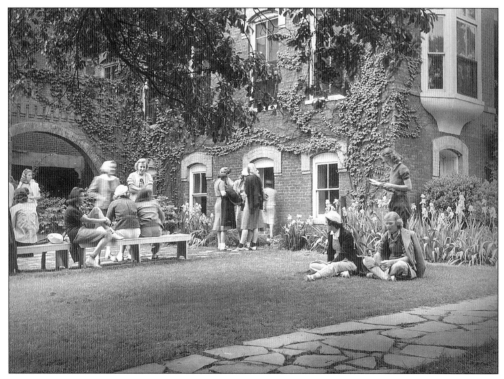

THE POST OFFICE. One of the most popular spots on campus was the front corner of West Wilson. The post office was located where the Commuting Students Lounge is today. Students would congregate on the benches and lawn outside to read their mail. The post office remained on this corner until it was moved to the new Montgomery Student Activities Building in 1960.

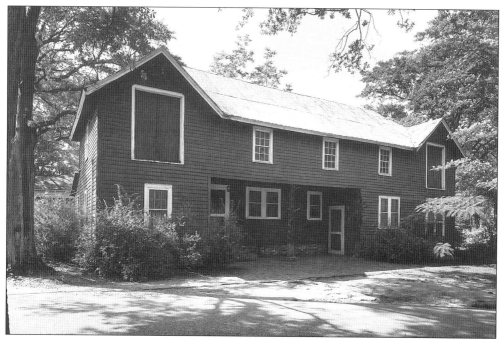

THE BARN. This barn was behind the residence that Benjamin and Sallie Wilson built adjacent to, but not a part of, the campus. When the Wilsons left in 1902, the property was sold to Mr. and Mrs. J.H. Sloan. In 1916, Mrs. Sloan allowed Margaret Hammond (Class of 1916) and Louisa Carlisle (Class of 1915) to use the barn as the Quaint Side Tea Room. In 1941, Converse acquired the back part of the Sloan property from Mrs. Sloan, including the barn. The barn was behind the Carnegie Building, where a parking lot is located today. (Photograph by Bradford Photography.)

LEE PARLOR. Redecoration of the West Parlor was made possible in 1934 by a gift from Mr. and Mrs. LeRoy Lee as a memorial to their daughter, Serena Lee Reynolds (Class of 1923). The transformation of the space into a Victorian parlor was carried out by Mildred Gwathmey and Mary Oeland Galbraith (Class of 1924). Lee Parlor remained unchanged until the 1950s. (Photograph by Alfred T. Willis.)

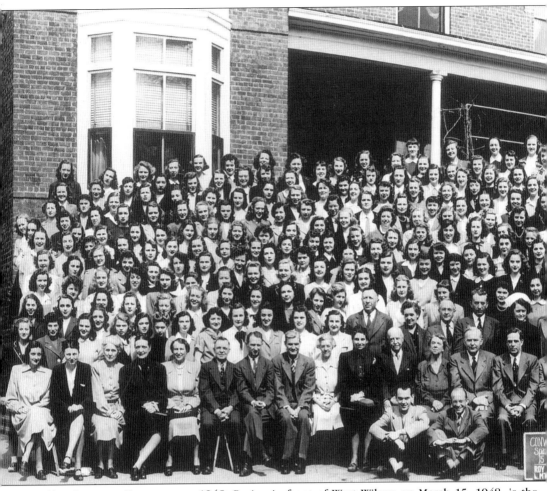

THE CONVERSE COMMUNITY IN 1948. Posing in front of West Wilson on March 15, 1948, is the entire faculty, administration, and student body. Pres. Edward Gwathmey is just to the left of the sign. To his right (facing the picture) is Edwin Gerschefski, dean of the School of Music. To

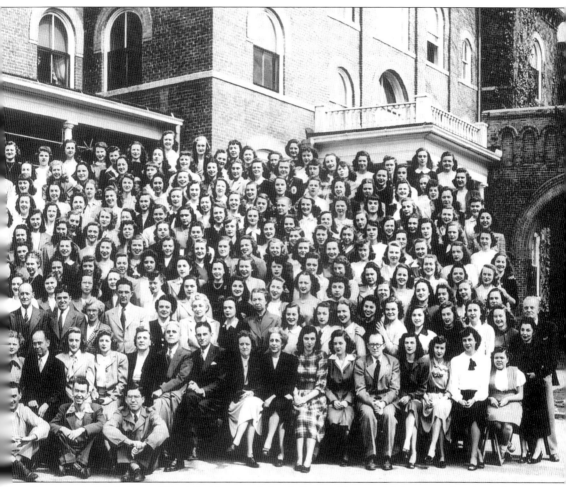

Gwathmey's left is Dean Elford C. Morgan of the College of Arts and Science, and to his left is Miss Gee. (Photograph by Roy D. Young Studio.)

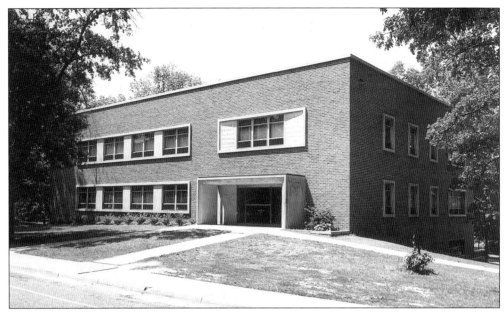

THE GWATHMEY LIBRARY. Louisa Carlisle spent the summer of 1947 visiting new college libraries. The architect chosen to design Converse's new library was J. Russell Bailey of Orange, Virginia. It was opened in 1951 but not named. Upon the retirement of Edward Gwathmey in 1955, the library was named in his honor. Construction costs ran a little over $195,000. (Photograph by B & B Studio.)

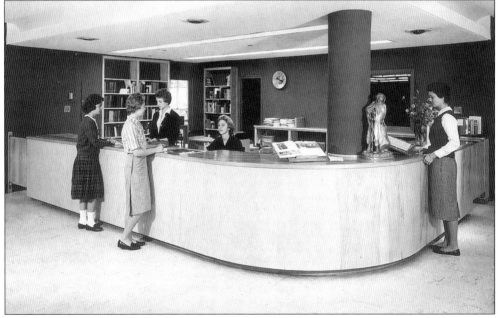

CIRCULATION DESK. The circulation desk was located just inside the entrance. When a large addition was built onto the library in 1981, the Gwathmey Library became the Gwathmey Wing of the new building. The site of the circulation desk (shown above) is now indiscernible on the second floor of the remodeled Gwathmey Wing. By the early 1950s, "penny" loafers were replacing saddle oxfords as standard footwear.

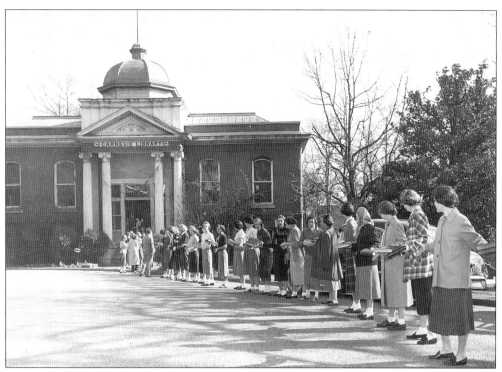

FROM THE OLD. On February 23, 1951, students and faculty lined up all across front campus and passed books from the Carnegie Library into the Gwathmey Library. The Carnegie Building is now used for administrative offices.

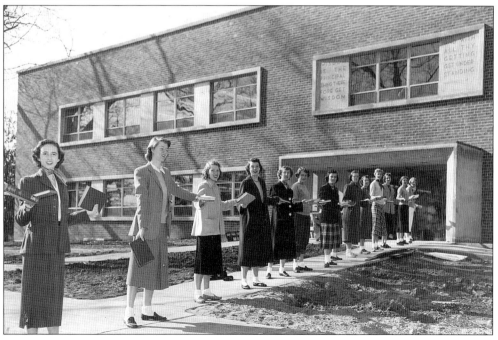

TO THE NEW. Students at the other end of the line pass books into the main entrance of the new building. During a two-hour period, they transferred 2,000 books.

LIBRARY ENTRANCE. At the library entrance, students display the rain wear of the 1950s. Loafers and white socks were standard come rain or shine. (Photograph by Atkinson and Gasque.)

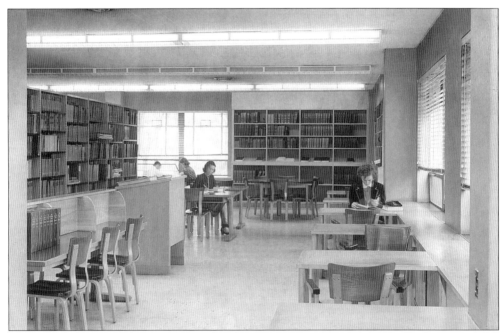

MODERN FLOOR PLAN. The book collection was spread out over all three floors. Study and reading areas were put adjacent to the stack areas. In this way, the collection was more accessible to users.

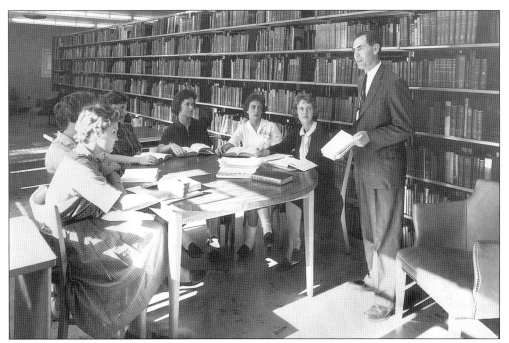

CHARLES D. ASHMORE. After the completion of the Gwathmey Library, the college still lacked adequate classrooms. Carmichael Hall and Kuhn Hall were yet to be built. Charles Ashmore is seen conducting an English class in the new library. He was professor of English from 1958 to 1982 and dean of the College of Arts and Sciences from 1961 to 1982. (Photograph by Piedmont Commercial Photographers.)

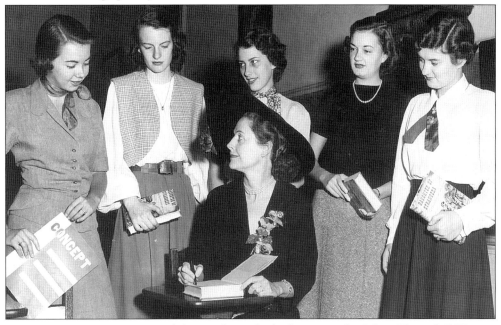

ELIZABETH BOATWRIGHT COKER. While a student, Elizabeth Boatwright Coker (Class of 1929), was active in the literary societies and student publications. The author of several novels, she is shown in the 1950s autographing a copy of her latest book during a visit to the campus.

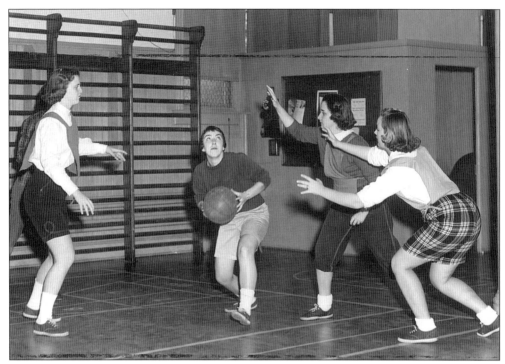

PHYSICAL EDUCATION. In the 1950s, Henrietta Browning was chair of the physical education department. She taught at Converse from 1924 to 1957. Her goal was to establish habits of recreation and exercise, which would carry on into a student's later life. All students had to take a team sport, an individual sport, and pass a swimming test to graduate.

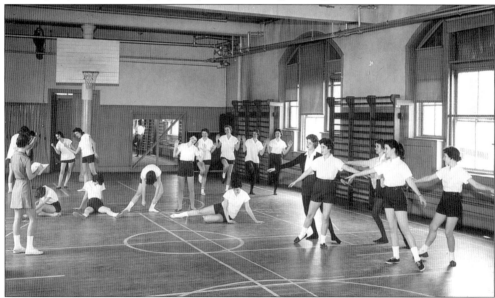

DANCE REQUIREMENT. By the late 1950s dance had been added to graduation requirements, in addition to individual and team sports. This scene is in the gymnasium of Dexter Hall. A regulation uniform—white shirts and blue shorts—was required for all physical education classes.

ELFORD CHAPMAN MORGAN. Dr. Morgan taught at Converse from 1932 to 1959, first in the History Department and then as professor of English. He replaced Miss Gee as dean of the College of Arts and Sciences in 1941. He served as acting president from 1955 to 1956, and then as dean of Administration until 1959. His English literature classes were so popular, he could fill them with students even at unpopular hours. As acting president and dean of Administration, he outlined a plan for upgrading all areas of college development that influenced future administrations.

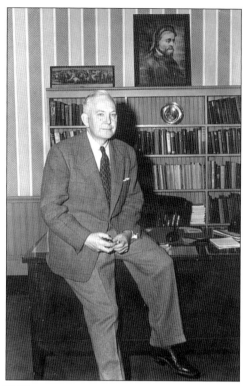

PAZ. Harriet Horn Pasmore changed her name to "Radiana Pazmor" for dramatic effect—not that a name change was necessary to achieve such a result. Born in San Francisco, she studied in Europe and New York. During the 1930s she was noted especially for her performances of contemporary American art songs. Tall and striking in appearance, she was known for her magnetic personality and her poise on stage. From 1941 to 1960 she was a member of the music faculty at Converse, often appearing in operas and theater productions. She died in 1969 at age 93.

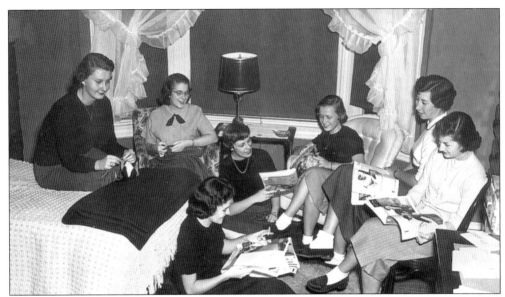

DORM LIFE. The 1950–1951 *Student Handbook* states that freshmen must turn off their lights at 11:30 p.m., Sunday through Friday, while the Saturday deadline was 12:00 a.m. They were allowed one light cut a month up to 1:00 a.m. Upperclassmen could turn off their lights at their discretion.

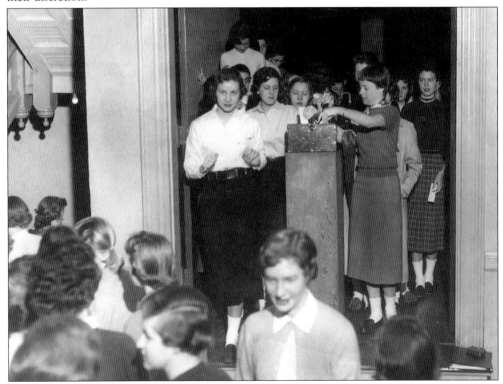

VOTING. A Student Government Association (SGA) was established at Converse in 1905. It was the second such system at a Southern college, with Randolph-Macon Woman's College being the first. Students voted for SGA and class officers.

DECORATING FOR CHRISTMAS. Decorating the lobby of Wilson Hall for Christmas was a part of the holiday season. Students would gather in the lobby before the Christmas break for the annual reading of "The Littlest Angel." (Photograph by B & B Studio.)

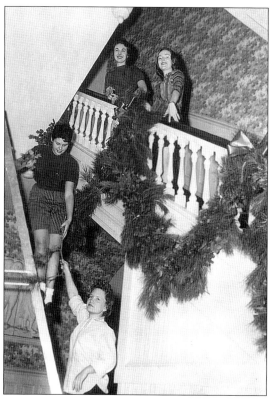

THE COTILLION CLUB. The Cotillion Club was responsible for planning the Christmas and spring dances. At the Christmas Dance in 1957, they all wore red dresses and performed a "figure." Pictured here, from left to right, are (seated) Jane Meadors, Mary Lib Spillers, Frances Hasell, Jane Haying, and Anne Morrison; (standing) Jane Powell, Judy Brewer, Patricia Hemingway, Gene Goley, Jane Torkington, Tapp Latta, Rochelle Thomason, and Jane Turner; (on the stairs) Temple Wright, Kay Kuykendall, Bunny Schipman, Betty Burgdorf, Sara Haynie, and Libby Long. (Photo by B & B Studio.)

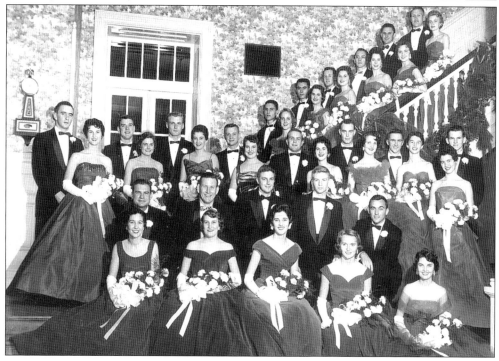

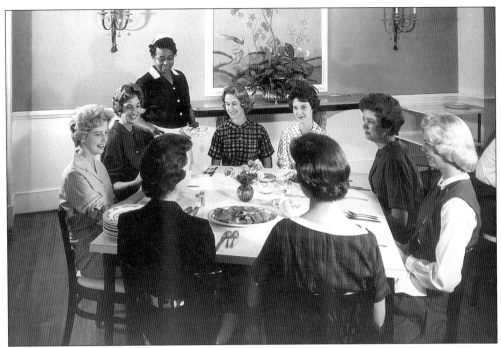

SEATED MEALS. Breakfast, lunch, and dinner were seated meals, served family-style in bowls and platters. This practice, with the exception of breakfast, continued until the 1970s.

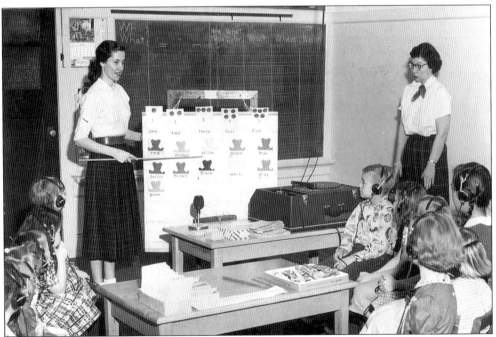

DEAF EDUCATION. In 1949, a program was established in cooperation with the South Carolina School for the Deaf and Blind, which made it possible for Converse students to qualify as teachers of the deaf. Josephine Prall was put in charge of coordinating the program, which was the first of its kind at any college in South Carolina.

THE CONVERSE COLLEGE TRIO.
Although the personnel of the
Trio has changed over the years,
its reputation for excellence
has not. Drawn from the music
faculty, the Trio's performances
have enhanced the reputation
of the School of Music. Shown
here, from left to right, are
Florence Reynolds, Edwin
Gerschefski, and Peggy Thomson
Gignilliat, Class of 1934.
(Photograph by B & B Studio.)

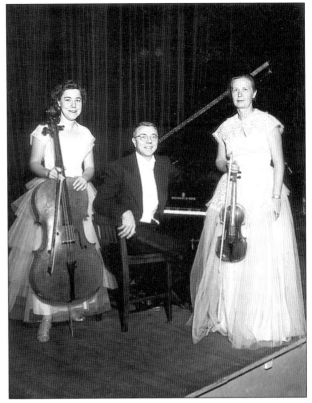

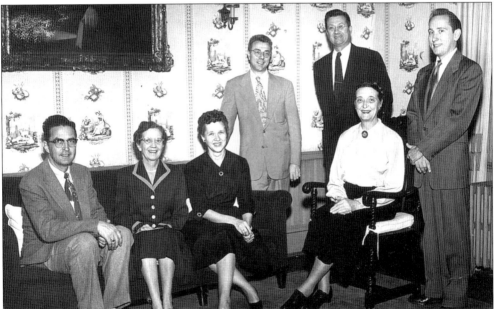

PI KAPPA LAMBDA. A music honor society, Pi Kappa Lambda is open to faculty and students who
have achieved in scholarship and performance. Pictured here, from left to right, are (seated) A.M.
White, Rachel Pierce, Alia Lawson, and Radiana Pazmor; (standing) Edwin Gerschefski, John
Erickson, and Henry Janiac. John Erickson was professor of piano from 1948 to 1982.

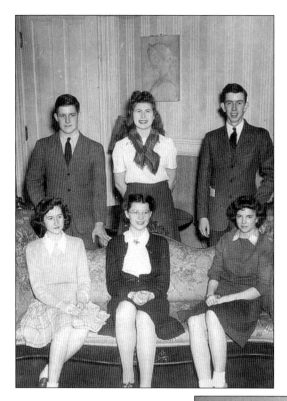

MUSIC SCHOLARSHIP WINNERS. For periods of time in the 1940s, 1950s, and the 1970s, the School of Music admitted male undergraduates. Scholarship winners in 1953–1954 were (seated) Margaret Gay, Sylvia Bodenhorn, and Claudia Dixon; (standing) Will Kennedy, Mary Katherine Pickett, and Carlisle Floyd. Floyd would achieve distinction as a composer of opera who wrote his own libretti. *Susannah* won the New York Music Critics Circle Award.

DOUBLE HONOR. In May 1958, Dean Elford C. Morgan was awarded an honorary degree by his alma mater, Wofford College. On the same day, Converse awarded the Mary Mildred Sullivan Award for service in the community to Martha Hamilton Morgan. Mrs. Morgan had taught in the Converse History Department. Also, on the same day, their eldest son graduated from Davidson College. (Photograph by B & B Studio.)

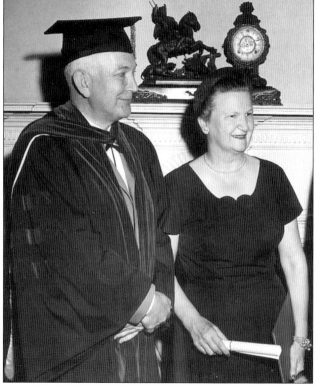

OLIVER C. CARMICHAEL JR. Converse College's fourth president served from 1956 to 1960. A Phi Beta Kappa graduate of Vanderbilt, Carmichael earned a law degree from Duke and a Ph.D. in public law and government from Columbia University. He and his wife, Ernestine (Ernie) Morris Carmichael contributed their talents and resources to upgrading Converse.

THE BLOCK HOUSE. While renovating their new home on Connecticut Avenue, the Carmichaels lived at the Block House, their home in Tryon, North Carolina. Part of the house was constructed as a fort during the Revolution. Students were frequently invited as guests. (Photograph by B & B Studio.)

488 CONNECTICUT AVENUE. In order to have ample space for entertaining, the Carmichaels enlarged the house they bought at 488 Connecticut Avenue. They created this large room overlooking the back garden. (Photograph by B & B Studio.)

RIDING RING. The Carmichaels were strong supporters of the equitation program. About 1958, a stable and riding ring were placed on the site of the future Blackman Music Building. In the mid-1960s, the riding ring was moved to the site of the lower playing field of the present-day Sally Abney Rose Athletic Complex on North Fairview Avenue. (Photograph by B & B Studio.)

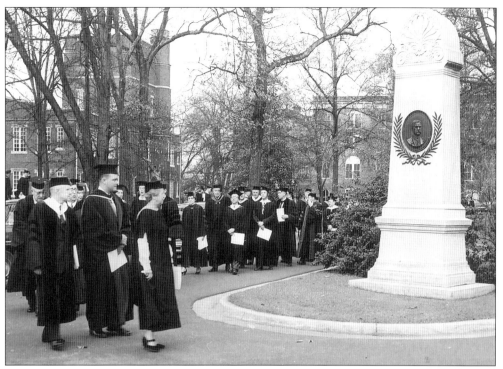

FOUNDER'S DAY. After the service in Twichell Auditorium, it was a tradition for the president to lead the trustees, faculty, and students to the Founder's Monument to place a wreath. In this late 1950s scene, the monument is west of its present location. Judd Science Hall appears through the bare trees on the left. (Photograph by B & B Studio.)

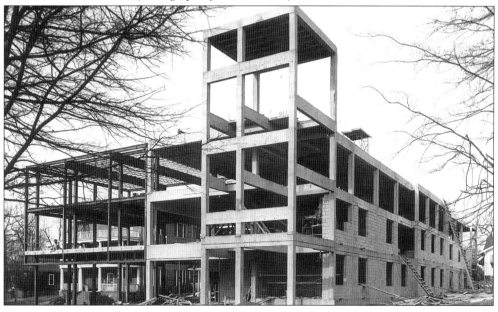

WILLIAMS HALL. President Carmichael embarked upon an active construction program. On October 17, 1958, Williams Hall was dedicated in honor of LuTelle Sherrill Williams (Class of 1905) and S. Clay Williams, long-time Converse benefactors. (Photograph by the Willis Studio.)

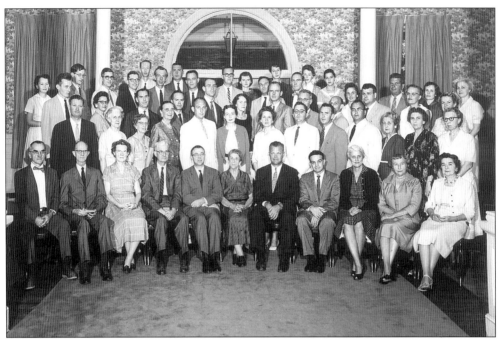

THE FACULTY, 1958. Miss Gee sits in the middle of the front row. On the far right of the front row is Lillian Kibler, who taught in the History Department from 1942 to 1962. Her doctorate was from Columbia University. After her retirement, she was asked to write a history of the college. Her first task was to assemble scattered source material, and the result became the nucleus of the current college archive. Her well-researched *History of Converse College* was published in 1973. (Photograph by B & B Studio.)

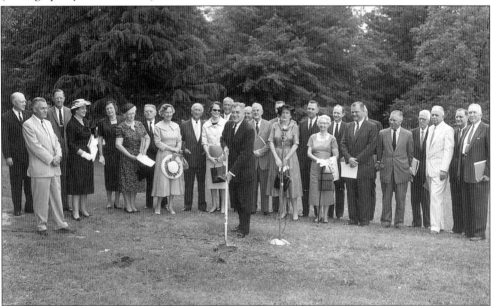

MONTGOMERY GROUNDBREAKING. In April 1959, the trustees gather for the groundbreaking of the Montgomery Student Activities Building. With shovel in hand is Walter S. Montgomery. (Photograph by B & B Studio.)

Four

EXPANSION AND CHANGE
1960s–1970s

The 1960s and 1970s were a time of change for Converse College. In 1960, when the obligation of managing a family business fell upon him, Oliver C. Carmichael resigned as president. Fortunately, his association with Converse did not end; he became chair of the Board of Trustees. Robert T. Coleman Jr., who was treasurer at the time, was asked to fill in until the search for a new president could be completed. A year later, it was decided that he was the right person to fill the job permanently. He would serve as president from 1961 to 1989. The 1960s and 1970s were decades of new construction and enrollment increases. In 1962, a graduate program in education and a summer session were established. In 1964, a Faculty Senate was created to involve the faculty in the governance of the college. In 1968, the traditional two-semester system was changed to a three-term calendar to facilitate off-campus study and internships. In 1972, the first endowed professorships were established.

MONTGOMERY STUDENT ACTIVITIES BUILDING. Dedicated in September 1960, the $825,000 facility was named in honor of three generations of the Montgomery family: John Henry Montgomery, a founding member of the Board of Trustees; Walter S. Montgomery (1866–1929), a former trustee; and Walter S. Montgomery (1900–1996), the chair of the Board of Trustees at the time.

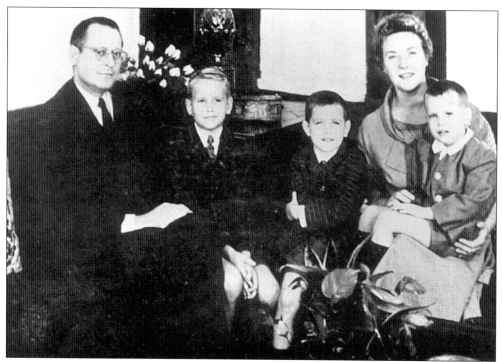

THE COLEMANS. Robert and Virginia Coleman are shown with their three sons, Bobby, Frank, and Bill. The new president was a Texan by birth and a graduate of the Harvard Business School. During his presidency (1961–1989), he got to know many students well and became known to them as "PC." A gracious lady, Virginia Coleman is one of the few persons to be made an honorary alumna of Converse.

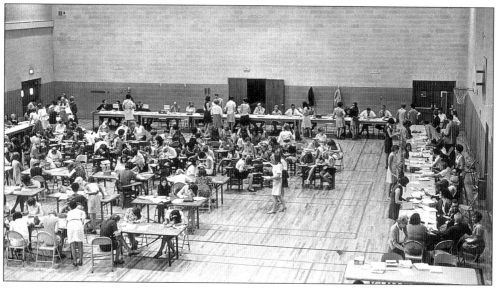

REGISTRATION. The new gym in the Montgomery Building provided space for registration at the beginning of each term. Faculty, arranged by departments, sat around the perimeter. Tables in the center provided space for students to fill out forms and try to find another class if their first choices were filled. (Photograph by Marvin Terrell.)

HALL TELEPHONES. In the 1960s, there were no telephones in dormitory rooms. The only telephones were located in the halls, and they were pay phones at that. The sign indicates a ten-minute limit on calls. This was an improvement over the 1920s and 1930s, however, when the only telephone for student use was in the lobby of Wilson Hall.

SOUTHERN LITERARY FESTIVAL, 1962. The English Department organized a Southern Literary Festival in the spring of 1962. Participating writers, from left to right, were William Davidson, Eudora Welty, Andrew Lytle, Flannery O'Connor, and Cleanth Brooks. In 1982, several of the participants returned for a 20th reunion. (Photograph by B & B Studio.)

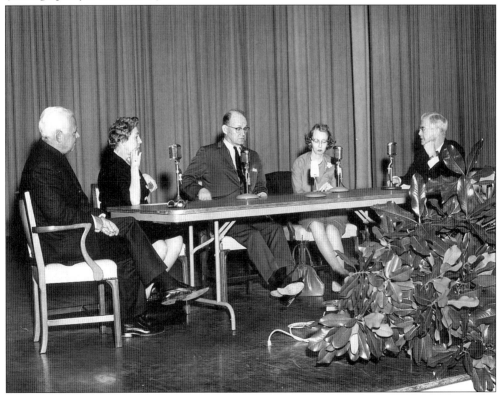

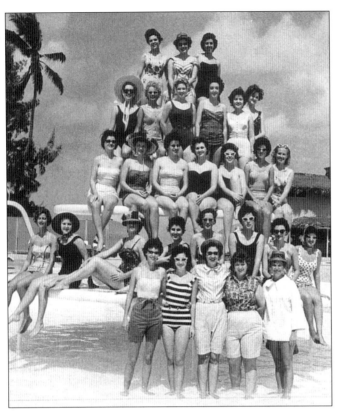

CHORUS IN NASSAU. Alia Ross Lawson joined the faculty in 1943. From 1958 to 1962, she led the Converse Chorus on a concert tour of several cities. Students tried out for the privilege. The college budgeted $1,000 for each tour. The group traveled by bus and was housed in the homes of alumnae. For the visit to Chicago, Eleanor Thomson Roy (Class of 1936) made all of the arrangements. The last tour, pictured here, was to Nassau. Alia Lawson is in the center of the front row. In 1945, she founded the Pre-College Department of the School of Music, which was named in her honor in 1998.

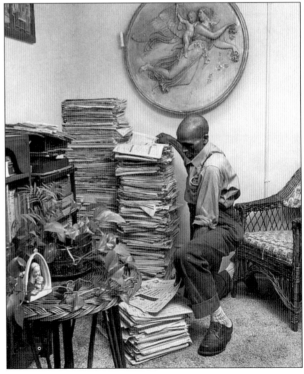

WALLACE GLENN IN MISS GEE'S OFFICE. Mary Wilson Gee died in 1963. Her office in Wilson Hall was filled with records of her 73 years on campus and of her trips to Greece and Italy. Wallace Glenn was a much respected college employee for 45 years and a close friend of Miss Gee. During her last years, Wallace Glenn escorted Miss Gee each morning from the Dean's Cottage to her office. He was known for the quiet dignity with which he laid the wreath at the Founder's Monument each April. Wallace Glenn died in 1973. (Photograph by Marvin Terrell.)

THE GWATHMEY GARDEN. In 1962, a new garden was dedicated to the memory of Mildred Bates Gwathmey. The idea was conceived by the Class of 1957 and financed by the alumnae. Planning was done by the South Carolina Federation of Garden Clubs, of which Sara Gossett Crigler (Class of 1907) was president. Gwathmey House, the former president's home, is barely visible through the trees to the right of Morris Hall.

CARMICHAEL HALL. The new classroom building was ready for occupancy when the second semester began in January 1963. Named in honor of Oliver C. Carmichael Jr. and Ernestine Morris Carmichael, it provided badly needed classrooms and faculty offices for the growing college. To clear the site for the new building, the 1890s cottages were moved. The Carmichaels were anxious that the building be functional but not institutional in appearance. An attractive entrance lobby was part of the plan.

91

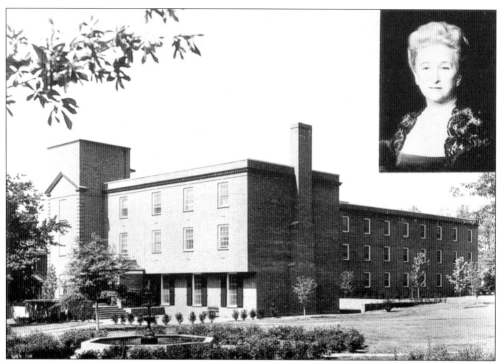

MORRIS HALL. On May 2, 1964, a second new dormitory was dedicated in honor of Ella L. Morris, a trustee and mother of Converse's former first lady, Ernestine Morris Carmichael.

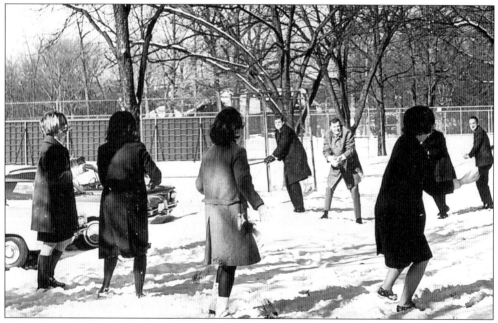

SNOW BATTLE. Doing battle on the faculty side of this snow fight are Nathaniel Magruder and Wolfgang Schlauch of the History Department and Andrew Howard of the Math Department. Snow or not, the dress code still applied to these students in 1966. Tights were allowed to keep legs warm.

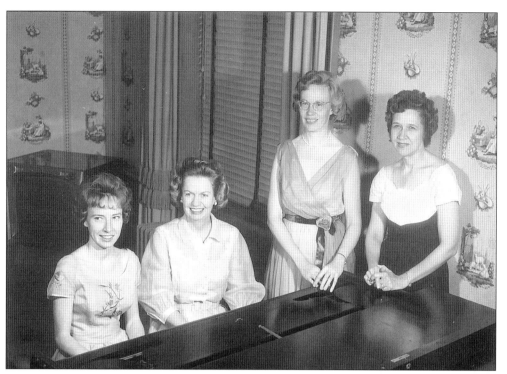

FOUR CONVERSE PIANISTS. Faculty from the School of Music posed prior to their four-piano concert in the mid-1960s. Four grand pianos were placed on the stage of Twichell Auditorium for the performance. Shown, from left to right, are Harriet Hair, Virginia McCall Gore, Eleanor Stanley White, and Alia Ross Lawson.

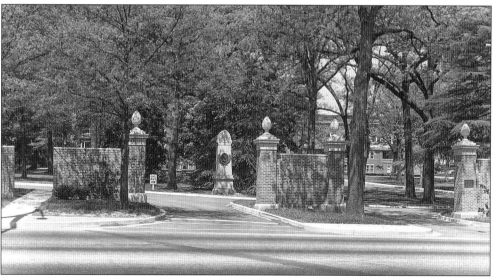

A NEW ENTRANCE. In 1967, a new main entrance was completed east of where the Pell Gates had been located. The Founder's Monument was also moved. The gate was dedicated in honor of Mary Burgin Presnell Montgomery (Mrs. Ben Montgomery), a liberal contributor. A new road system meant that it was no longer possible to drive from front to back campus. Converse was to become a pedestrian campus. A fence was put around part of the campus at the same time.

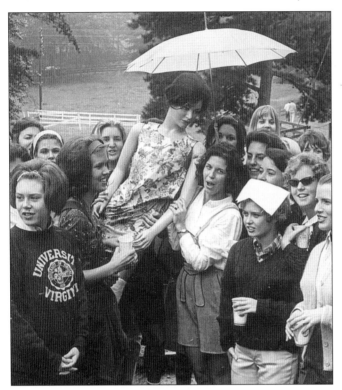

MODINE. Before there were Pink Panthers and Red Devils, there was Modine. She was the class mascot for the odd-year classes in the late 1960s and early 1970s and was proudly carried about during D Day celebrations and other class events.

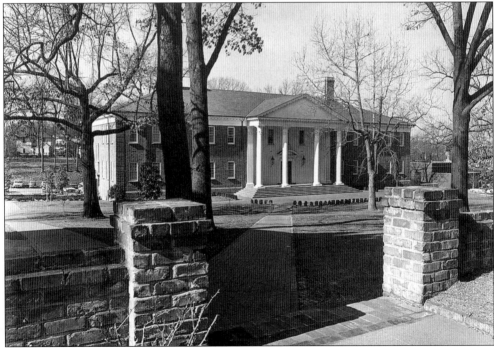

KUHN SCIENCE HALL. In October 1967, the science departments and the Psychology Department moved from Judd Hall into their new building, which was named for Willis E. Kuhn and Jacquelyn Montague Kuhn, members of the Board of Trustees. (Photograph by Joe F. Jordan.)

ROSAMONDE RAMSAY BOYD. Dr. Boyd joined the Sociology Department in 1937 and retired in 1971. Lillian Kibler described her as a woman "of charming personality and brilliant intellect." In addition to being a popular teacher, she was active in a number of educational and social service organizations on the local and national level. She was especially active in the American Association of University Women and served as national chair of that organization's Status of Women Committee. After retiring from Converse, she devoted much of her time to the cause of senior citizens. Rosamonde Boyd died in 1993.

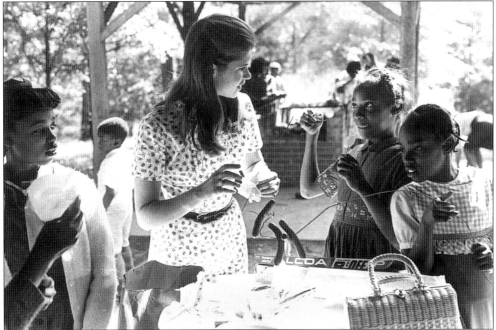

COMMUNITY SERVICE. Converse students have always been involved in the community. During her junior year, Marsha Katz (Class of 1969) and several other students worked with a Girl Scout troop at the Bethlehem Center in Spartanburg. (Photograph by Marvin Terrell.)

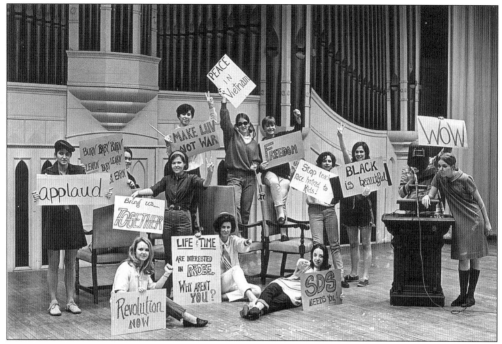

MORTAR BOARD. In 1967, the Order of the Gavel became the Gavel Chapter of Mortar Board, a national senior honor organization for women. In 1969, Mortar Board sponsored a symposium concentrating on the issues of the 1960s. Above, members and helpers pose with signs representing the issues to be discussed during the first Probe. (Photograph by Marvin Terrell; courtesy of Adelaide Capers Johnson.)

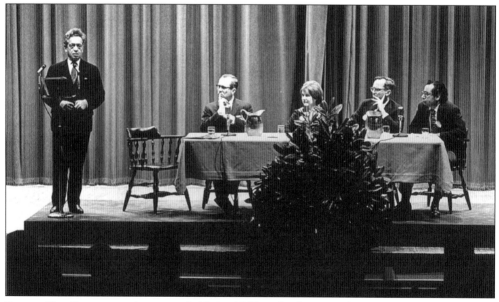

PROBE. The first symposium was held in 1969 with the topic being "Decade of Dissent." Participating were: Max Lerner of Brandeis University; Willian Rusher, the publisher of the *National Review*; Lilith Quinlan, president of Mortar Board; Roger Shinn, dean of Union Theological Seminary; and Jack Newfield, assistant editor of the *Village Voice*.

BELK HALL. On October 10, 1969, the last dormitory to be built on campus was dedicated to the memory of William Henry Belk and John Montgomery Belk, the founders of the Belk Department Stores. Support for the construction of the dormitory was given by the Belk Foundation. (Photograph by Marvin Terrell.)

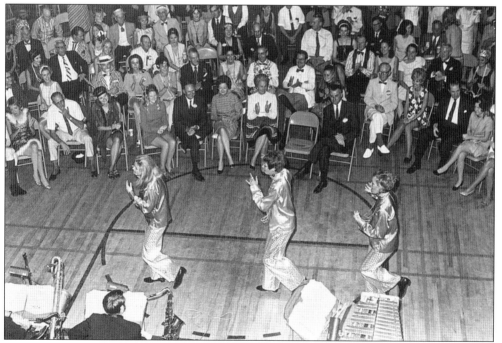

THE CONVERSE SUPREMES. For several years, Stuart Rinehart, Lynnie Hicks, and Perry Hicks (all of the Class of 1970) delighted audiences at D Day and Parents' Weekends. Their lip-sync act presented a real challenge to Diana Ross and the popular singing group.

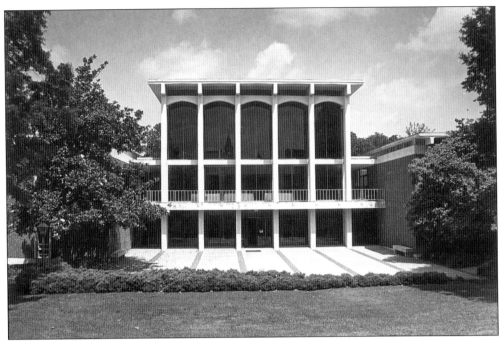

BLACKMAN MUSIC BUILDING. The new home of the School of Music was made possible by a contribution from Margaret Blackman O'Herron (Class of 1938) and Percy Clarke Blackman in memory of their mother, Mary Bays Blackman (Class of 1898). Blackman Music Building was dedicated on October 23, 1970. It was designed by the same architect as Lincoln Center.

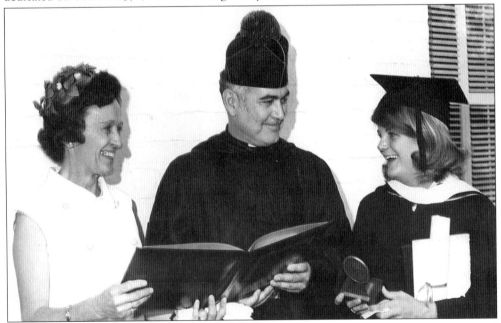

COMMENCEMENT, 1970. The speaker in 1970 was the Rev. Theodore M. Hesburgh, president of Notre Dame University. Myrt Craver Riggs (Class of 1940) received the Mary Mildren Sullivan Award for service to the community. The student recipient of the Sullivan Award was Karen Clarke. (Photograph by B & B Studio.)

REQUIRED ASSEMBLIES. Students had to hurry from class to Twichell Auditorium for assembly and chapel programs twice a week in the 1960s. These meetings were at 10:00 a.m. on Monday and Wednesday. When the three-term calendar went into effect in 1968–1969, assemblies were at 11:30 a.m. on Tuesday and chapel was at 11:30 a.m. on Thursday. Limited cuts were allowed. These meetings were followed by a seated lunch at 1:00 p.m. In 1970–1971, chapel attendance became voluntary, and only a few assemblies were required during the year. In the background, through the porte-cochere can be seen Judd Science Hall.

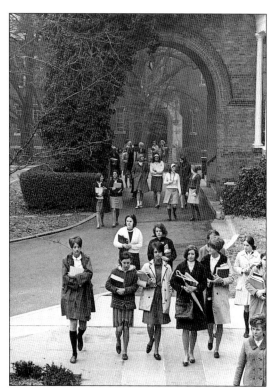

MAE KILGO. A member of the Class of 1936, Mae Kilgo later returned to work for her alma mater. Over a period of 34 years she worked in the areas of recruitment, fund-raising, and career and job placement, and she served as director of Alumnae Affairs. Converse awarded her both the Distinguished Alumnae Award and the Mary Mildred Sullivan Award. In 1985, the college renamed the Spirit of Converse Award the Mae Elizabeth Kilgo Spirit Award. (Photograph by B & B Studio.)

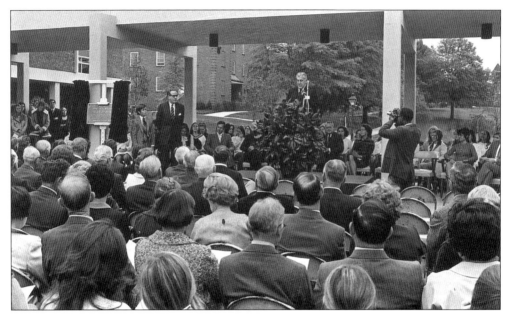

MILLIKEN FINE ARTS BUILDING. Dedicated on October 20, 1971, in memory of Gerrish Hill Milliken, the new facility supplied the need for an expanding program in the visual arts. Traveling exhibits and student shows were provided space in a new gallery. Walter S. Montgomery (at the podium) recognized the contributions of Roger Milliken (standing left). Thirty years later additional space was needed again. In the spring of 2001 ground was broken for a large addition to the building, which will be named in honor of Nita Milliken. (Photograph by Terrell Photography.)

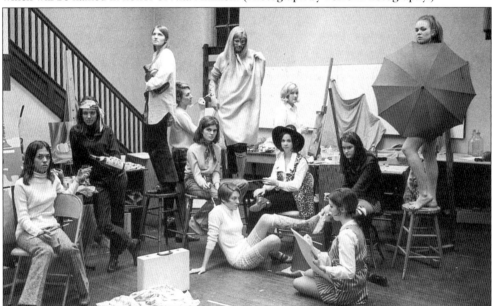

THE EXHIBITIONISTS. The Exhibitionists was organized in 1969–1970 by students interested in art and its promotion. Pictured in this photograph, from left to right, are Martha Cesery, Bobby Smith, Ridgely Harrison, Fran Cox, Betsy Lingo, Laura Baumberger, Mason Laird, Amanda Johnson, Nadia Nightingale, Ruth Walston, Debbie Lea, and Ann Chandler. The number of art majors was growing at this time.

APPLAUSE FOR THE FACULTY. It is a tradition at Converse for the members of the graduating class to line up between Wilson Hall and Twichell Auditorium and applaud the faculty as it proceeds to the Auditorium for graduation. It this view, faculty marshals Virginia Gore and Eleanor White lead the faculty procession.

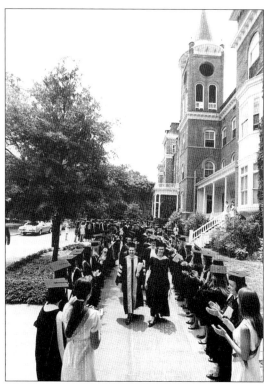

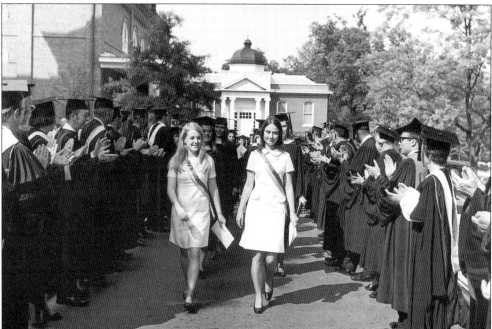

APPLAUSE FOR THE GRADUATES. It is also a part of the Converse tradition for the faculty to line up outside of Twichell Auditorium after graduation and applaud the graduates as they emerge from the Auditorium. On graduation day in 1969, student marshals Brenda Bradshaw and Wanda Gilmer led the graduates into the world. (Photograph by Marvin Terrell.)

R. Henry Gallman. At one time, the Converse campus was known for the beauty of its rose gardens. The person primarily responsible for that reputation was Henry Gallman, who worked on the college grounds from 1939 to 1977. He had a special talent for growing roses. Upon his retirement in 1977, the rose garden around the fountain on back campus was named the Henry Gallman Garden.

Hoofbeats, 1972. In the mid-1960s, the riding ring on back campus (see page 84) was moved to a site on North Fairview Avenue now occupied by the playing field of the Sally Abney Rose Athletic Complex. The Barn (see page 69) was moved to the new site and served as a tack room.

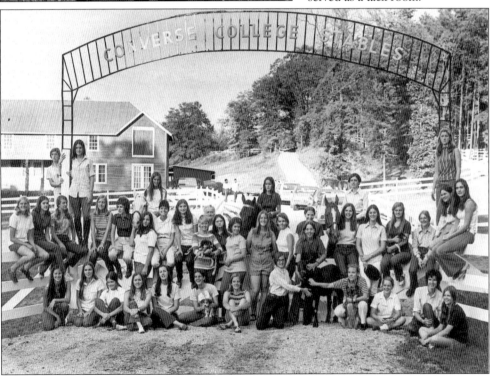

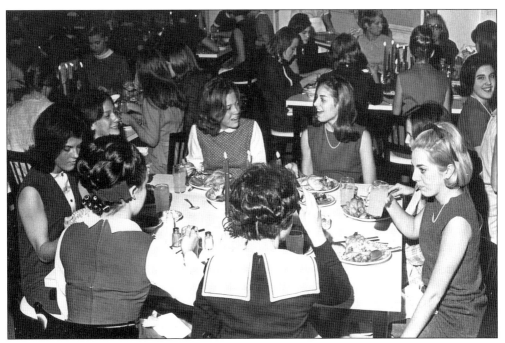

CHRISTMAS DINNER. Part of the Christmas celebration at Converse is a special dinner served in Gee Dining Hall. Turkey and dressing and candlelight enhance the occasion. (Photograph by B & B Studio.)

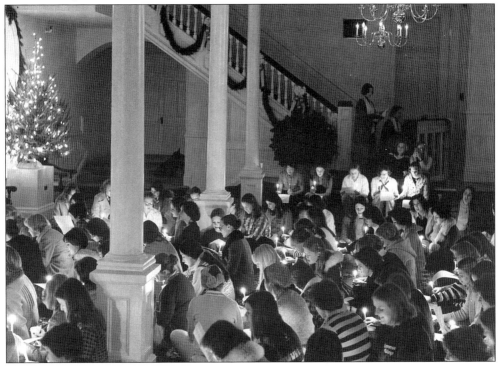

MORAVIAN LOVE FEAST. The Christmas season continued as students gathered in the lobby of Wilson Hall for a traditional Moravian Love Feast of candlelight and Christmas songs.

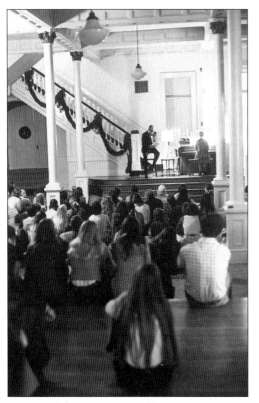

"THE LITTLEST ANGEL". For many years at Christmas, John McCrae read the story of "The Littlest Angel" in Wilson Lobby. McCrae already had an extensive career in concert, oratorio, and opera when he joined the School of Music faculty. He was professor of voice and opera at Converse from 1952 to 1982 and served as director of the Opera Workshop. Professor McCrae died in 1986. (Photograph by Terrell Photography.)

LESSONS AND CAROLS. The culmination of the Christmas celebration takes place in Twichell Auditorium with the Festival of Lessons and Carols. The service consists of readings from scripture and Christmas music performed by the Converse Chorus. (Photograph by Terrell Photography.)

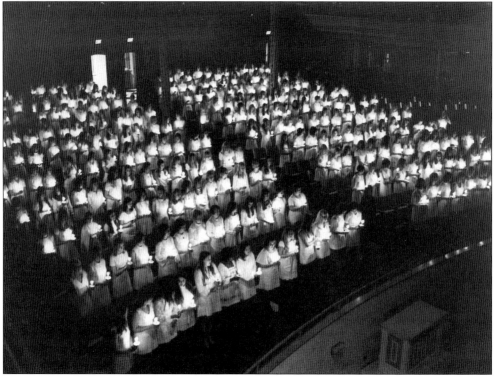

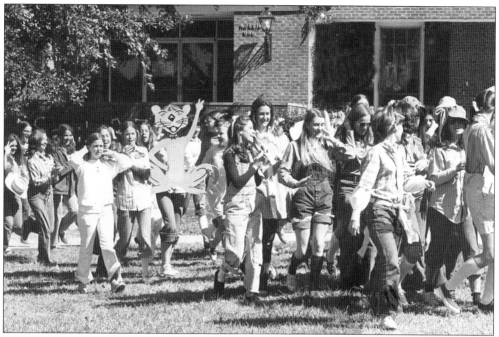

D Day. Rat Week, including freshman beanies, was an old tradition at Converse. In 1959, it was changed to a time of activities for the entire college and was renamed D Day. In the 1960s and 1970s, classes were canceled on a Friday, and students and faculty would adjourn to the Block House in Tryon for the day. The Class of 1966 claims the honor of being the first even-year class to adopt a popular movie character, the Pink Panther, as their mascot. The slinky feline first appears in *Ys and Other Ys* in 1969. (Photograph by Terrell Photography.)

Pearson's Falls. In the afternoon of D Day, seniors would leave the Block House and adjourn to nearby Pearson's Falls for a celebration. (Photograph by Marvin Terrell.)

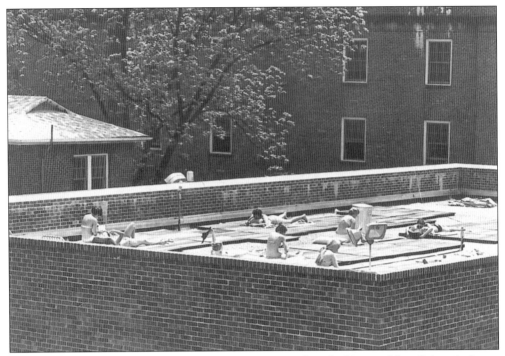

SUNBATHING. The advent of flat-roofed dormitories invited sunbathing and low-flying airplanes. Concerned that a student might fall off the roof, the college eventually prohibited roof-top sunbathing. (Photograph by Terrell Photography.)

ENGAGEMENT PARTY. The tradition remains today that a student who has just become engaged be thrown into the pool in the Gwathmey Garden. (Photograph by Marvin Terrell.)

106

DEXTER RESIDENTS. Residents of Dexter Hall in the late 1970s happily pose for what was probably a D Day photograph. They assembled outside the new back entrance, which in 1961 had replaced the 1915 swimming pool addition. Also in 1961, the gymnasium was transformed into two floors of air-conditioned residence rooms. The neo-classical front entrance was replaced by a less elaborate brick porch.

THE LONDON TERM, 1976. The first London Term was organized in 1970 by John Byars of the English Department and Jeffrey Willis of the History Department. This picture was taken in 1976 in the English town of Rye. Originally a three-month program in the fall term, the London Term was moved to the winter term in 1996.

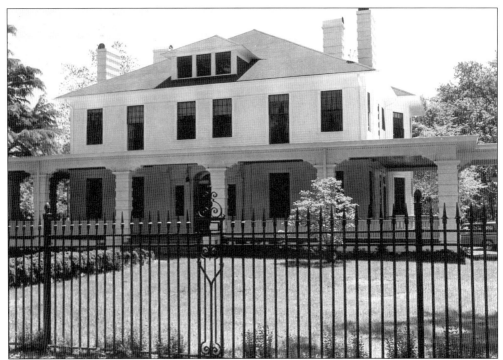

CLEVELAND ALUMNAE HOUSE. Located just across Main Street from the college, this house was built in 1905 by Aug W. and Belle Smith. For many years it was the home of Arthur F. and Chevillette Cleveland, whose heirs gave it to Converse in 1974. The Spartanburg Alumnae organized a very successful Designers Show House to raise funds to decorate and furnish the home.

THE HONOR PLEDGE. In 1916, the Student Government Association implemented an honor system. During each fall term, members of the Honor Board oversee the signing of the honor pledge by the new freshman class. The honor system is perhaps the strongest tradition at Converse. (Photograph by Terrell Photography.)

ORCHESIS, 1973. The modern dance club impresses audiences during their spring performance each year. Shown here, from left to right, are (first row) Julie Forbes, Leila Evarts, Beth Keels, Anne Walker, and Prof. Janis Dengler; (second row) Jan Jones, Gaye Cuthbertson, Kathy Dreher, Kimberly Keogh, Carolyn Cathey, and Barbara Bryant; (third row) Mary Lee Peck, Nancy Davis, Linda Balish, Alice Pearce, Lolly Ballard, and Barbara Lyles. Janis Dengler taught in the Physical Education Department from 1960 to 2001. (Photograph by Terrell Photography.)

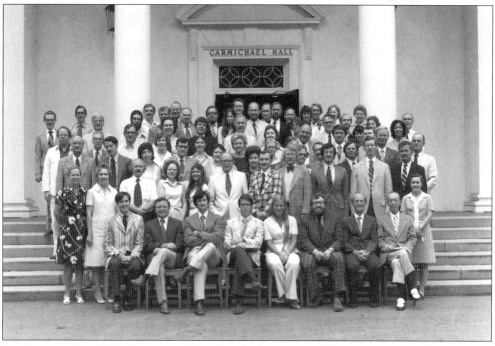

THE FACULTY, MID-1970S. For several decades, the faculty posed for a group picture following the opening faculty meeting in September. (Photograph by Marvin Terrell.)

CAFETERIA STYLE. In the mid-1970s, lunch ceased to be a seated meal served at 1:00 p.m. A cafeteria system was implemented, including a popular salad bar. The evening dinner continued to be a seated meal until the 1990s.

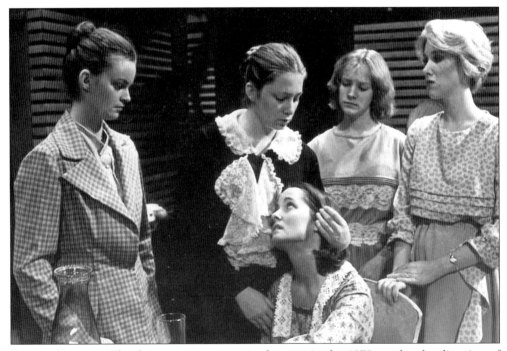

THEATRE CONVERSE. The drama program remained strong in the 1970s under the direction of Heyward Ellis. "Ladyhouse Blues" was performed in the fall of 1977 and starred Betsy Ball Harper, Melissa Severance, Terry Gardner, Melissa Hatfield, and Debra Bottoms (seated). (Photograph by B & B Studio.)

POSTMISTRESS. For students, one of the most important and visited sites on campus is the post office. At one time, Miss Gee would stand in Wilson Lobby and call out the names of those who had mail. Later, the post office was installed in the ground floor of West Wilson, where the Commuting Students Lounge is located today. When the Montgomery building was opened in 1960, provision was made for a new post office. From 1960 to 1989, Juanita Woods ably served as postmistress.

CRESCENT. In 1915, a group of freshmen formed a secret society called the Freshman Order of Rats. In 1945, F.O.R. dissolved itself and formed a non-secret leadership society for underclassmen. The new organization was named Crescent. Today, Crescent is a sophomore society dedicated to unselfish leadership, scholarship, and integrity. The group shown above is from 1977–1978.

MAINTENANCE STAFF. Converse has been fortunate in having maintenance staff who remained with the college for many years. Shown from left to right are Buford Bennett, Homer Byrd, Glenn Wood, and Roger Bridges. The latter has been on the staff since 1976 and is currently maintenance manager.

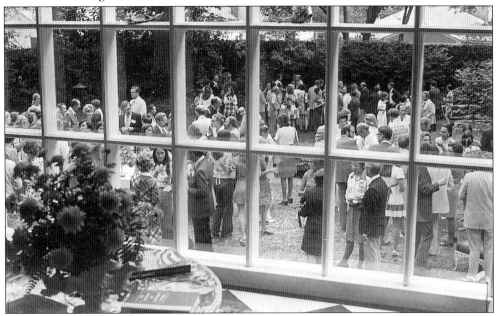

GARDEN RECEPTION. When the Carmichaels left, they gave the house at 488 Connecticut Avenue as a president's home. The Colemans regularly used the garden to entertain alumnae, freshmen, seniors, and their families.

Duet. Perry Daniels and Jane Frazier Rolandi enlivened the voice department and delighted audiences for many years. Daniels taught from 1965 to 1994. Rolandi was on the music faculty from 1963 to 1989. Both often performed in the spring opera

Joanne Jolly. Mrs. Jolly has been an administrative assistant in the Education Department since 1963. Education majors and graduate students seeking certification have found her to be a valuable source of both information and comfort. In 2001, she graduated from Converse with a major in business administration.

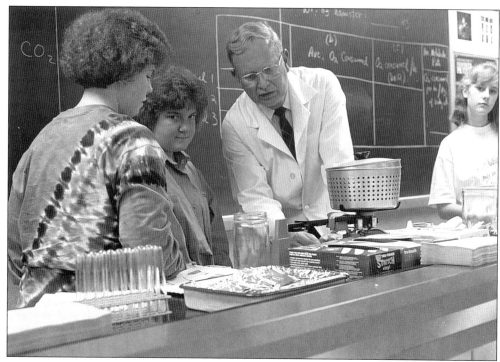

BOTANY BOB. Robert W. Powell taught in the Biology Department from 1963 until 1999. Often he could be seen pointing out the characteristics and special qualities of the plants and trees on the campus during class excursions. Anyone who contemplated cutting down a tree on campus found it wise to check with him first.

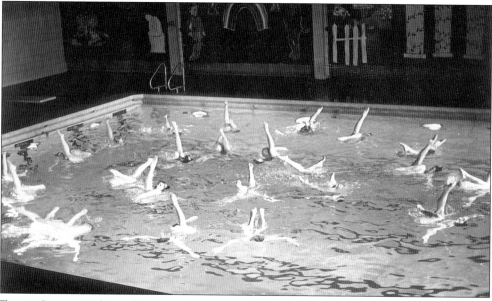

TARPON SHARKS. Each March, the Tarpon Sharks Swim Club stages a water show. Much time goes into planning the theme, making a large backdrop for the pool area, and endless practicing for the numbers. Prof. Gayle Gravlee Magruder directed and inspired the program from 1967 to 2001. (Photograph by Terrell Photography.)

HOCKEY TEAM, 1979. As during the early years, sports have remained a popular activity. Pictured here from left to right are (front row) Martha Dicus, Penny Cummings, Carol Baylor, Linda Harney, and Jeannie Blackmon; (back row) Coach Margaret Moore, Cathy Hartley, Dena Stone, Margaret Harvey, Carol Upchurch, Dot Cherry, Sally Herlong, Cathy Hindman, Libby Heberton, and Louise Bixler.

WILLIAM REED. This genial gentleman cared for the campus grounds for more than 20 years and was an accomplished bricklayer as well. He was sociable and enjoyed chatting with both students and faculty. In 1984, the students dedicated the *Y's and Other Y's* to him. William Reed retired in the early 1990s.

115

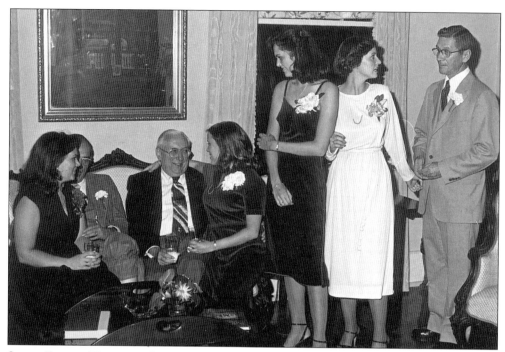

SENIOR FATHERS WEEKEND, 1979. A special time for seniors came every November. On Saturday evening, after dinner in the Gee Dining Room, the fathers escorted their daughters to a gala dance held in the Cleveland Alumnae House. (Photograph by Terrell Photography.)

HENRY JANIEC. Henry Janiec was a member of the music faculty from 1952 to 1994. From 1967 to 1994, he was dean of the School of Music. He was also conductor of the Spartanburg Symphony Orchestra and artistic director of the Brevard Music Center.

Five

CENTENNIAL AND BEYOND

1980s–1990s

By the last two decades of the 20th century, relaxation of dress codes and social rules produced a much more informal atmosphere on campus. Villager blouses, skirts, and sweaters were replaced by sweatshirts in colder weather and tee-shirts and shorts in the warm season. Saddle oxfords and penny loafers were replaced by tennis shoes. Male visitors were no longer confined to chaperoned parlors in Wilson Hall; they could now visit in dormitory rooms during specified hours. The one telephone in Wilson Lobby, and later the hall phones, were replaced by a phone in every dormitory room if not in every pocket. Internet connections in each dormitory room connected the Converse student with the world. The student body became more ethnically diverse and sensitive and more service-minded. Along with inevitable changes, many traditions continued. Converse students were still proud of their honor system. The big sister/little sister tradition still created a bond between the classes. The Converse student now graduated better prepared but still carried with her friendships that would last a lifetime.

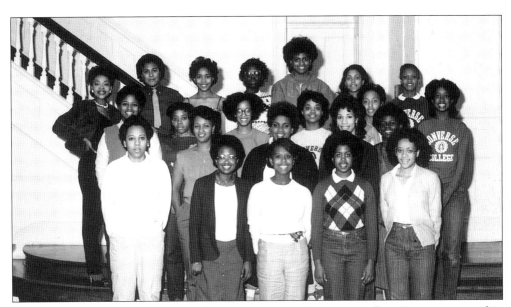

MINORITY STUDENT UNION. The first African-American students to enroll at Converse entered in September 1968. In the 1980s, a Minority Student Union was organized to promote the benefits of cultural differences. The MSU sponsored speakers and seminars, and they organized a successful Black History Month.

117

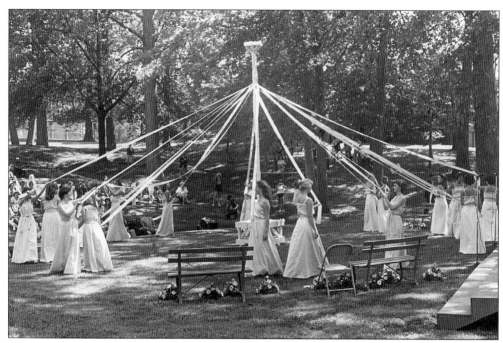

MAY DAY, 1982. One of the traditions that continued was the annual crowning of the May Queen. Although attendance no longer numbered 3,000 in 1982, the attendants still entwined ribbons around the May Pole for the entertainment of the Queen.

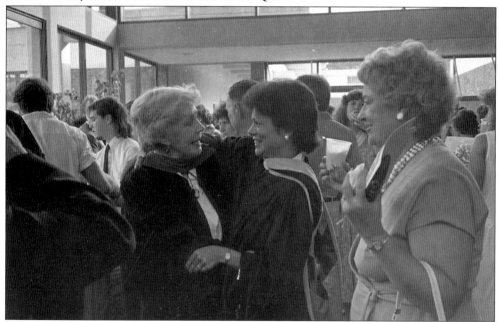

GRADUATE EDUCATION. The Master of Arts in Teaching program was begun in 1962. David Stoney was the first director. Later the degree was changed to a Masters in Education but has been changed back to a M.A.T. in 2001. Martha Lovett (on the left) came as director of Graduate Education in 1986. In 1995, she became the first dean of Graduate Education. The program is so large it requires its own commencement.

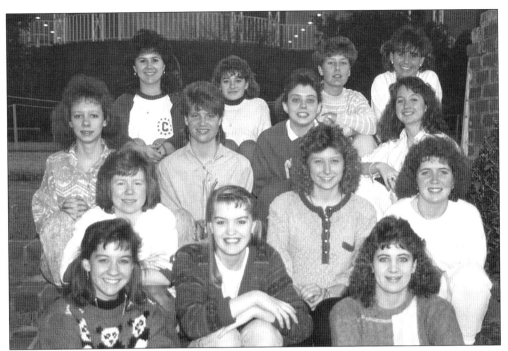

STUDENT VOLUNTEER SERVICES. This new organization emerged in the 1980s to allow students to become involved in service projects. Working with deaf children was just one of their activities. Shown here from left to right are (front row) Genny Hill, Kim Hunter, and Angela Heider; (second row) Katherine Van Horne, Tonya Miller, and Jill Clark; (third row) Stacy Brabo, Suzanne Sikes, Mary Dodrill, and Coni Williams; (fourth row) Jenn Fawbush, Becca Wood, Margaret Myers, and Kelly Callahan.

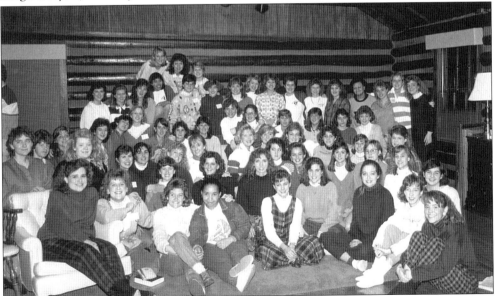

STUDENT CHRISTIAN ASSOCIATION. Since its organization in 1898, the Young Women's Christian Association was active on campus. In 1953, it renamed itself the SCA. Today it provides an opportunity for students to act upon their beliefs on the campus and in the community.

119

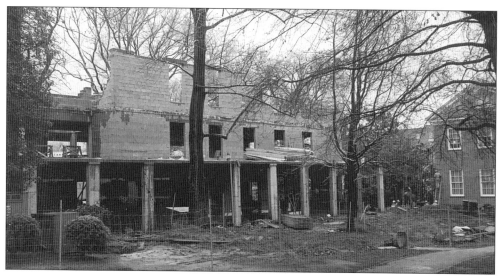

MICKEL LIBRARY. In 1981, construction was completed on a project that doubled the size of the library. In 1986, the new building was named for long-time supporters Buck and Minor Mickel. The 1951 section of the building was designated the Gwathmey Wing of the Mickel Library. Head librarian James G. Harrison played a major role in planning the new facility.

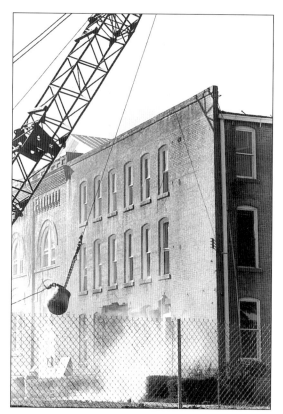

REBIRTH OF TWICHELL AUDITORIUM. From 1987 to 1989, Twichell Auditorium was rebuilt. The large section of practice rooms on the rear was demolished. Only the front and side walls of the auditorium were left. A new auditorium was built inside. Attached to one side was a large wing to accommodate the Pre-College Department of the School of Music. (Photograph by B & B Studio.)

COLLEGE BIRTHDAY PARTY. In 1989, Converse College celebrated its centennial. The chair of the centennial committee was Joe Ann Lever (right). She is assisted in cutting the cake by long-time trustee Nita Milliken. Joe Ann Lever joined the Biology Department in 1962. From 1990 to 1994, she was associate dean of the College of Arts and Sciences. Since 1994, she has been dean.

TODAY AT CONVERSE. On May 4, 1989, Willard Scott was greeted upon his 6:30 a.m. arrival by 500 cheering students sporting Willard masks and waving signs for their parents and hometowns. Scott broadcast his portion of the *Today* Show from the campus. He chats here with President Robert Coleman.

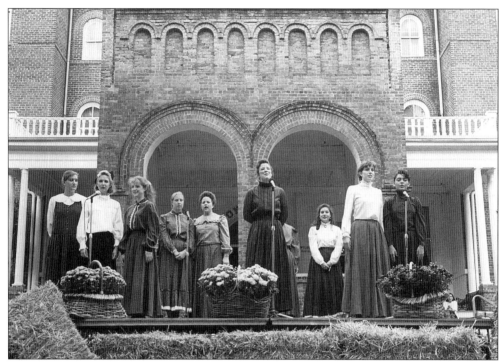

REOPENING, OCTOBER 1990. On October 1, 1990, students, dressed in the styles of 100 years ago, reenacted the opening of the college on October 1, 1890. A stage was built in front of Wilson Hall for the skit.

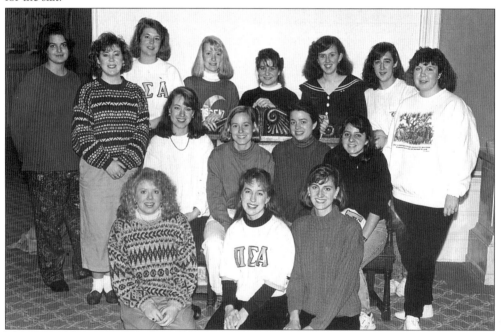

W.I.S.E. Women Involved for a Safer Environment consists of students who are committed to promoting environmental awareness on campus. They are involved in recycling glass, aluminum, plastics, and paper.

RICHARD, THE RED DEVIL. The toothy imp replaced Modine as the mascot of the odd-year classes in the mid-1970s. He first appears in *Ys and Other Ys* in 1975. The sophomore class officers of the Class of 1991 proudly paraded the Red Devil during 1889 Week activities. Shown seated from left to right are Sonya Harmeyer and Lori Mulliwee; standing are Liz Sanders and Wanda Moore. Under the influence of the 1989 Centennial, D Day had been renamed "1889 Week."

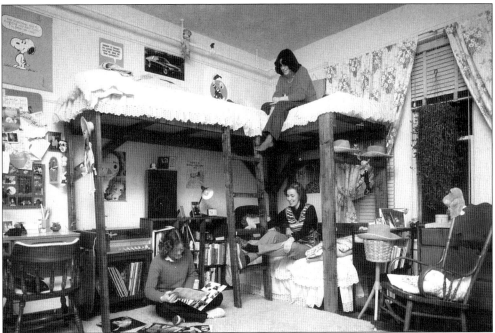

THE AGE OF THE LOFT. To accommodate computer stations and other equipment in a limited space, students in the 1980s and 1990s began constructing lofts which could be moved to other rooms and sold to incoming students. Quiet hours were still observed in the residence halls from 7:00 p.m. to 7:00 a.m., Sunday through Thursday.

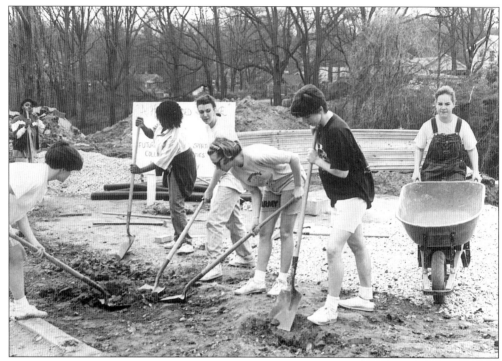

HABITAT FOR HUMANITY. Among the community service programs which students involved themselves in the 1990s was building homes for low-income families.

CONVERSE II. In 1983, Converse began an advisory and support program for non-traditional-age undergraduate women. Shown from left to right prior to their 1995 graduation are Mary Dial, Meralyn Field, and Marty Shurburtt. Sandra Thomas (second from right) was president of Converse from 1994 to 1998.

MODEL LEAGUE OF ARAB STATES. In 1988, Joe Dunn of the History and Politics Department organized the first Converse team to participate in a national conference in Washington. The Converse delegation has always won top awards. The 1989 delegation, shown above from left to right, are (seated) Mary Galen Robinson, Lisa Wimberly, and Angela Denton; (standing) Dawn Hammer, Sally Lee, Gwynne Brown, Shayna Goering, Kirs Amos, Kim Underwood, Beth Benston, and Joe Dunn.

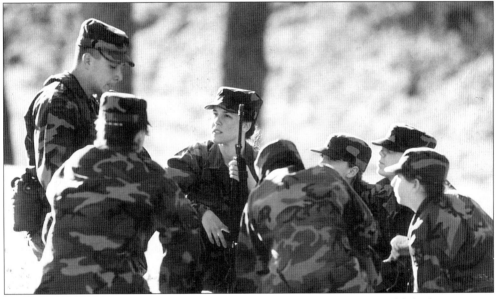

S.C.I.L. The South Carolina Institute of Leadership for Women was established in 1995 to provide women the same leadership training that was available in military colleges. The members of the corps shown here were receiving training at Fort Jackson in the use of the M-16 rifle. The denial of state funding and the advent of coeducation at The Citadel ended the program in 1999. The program has been replaced by a four-year Institute for Leadership, which emphasizes leadership roles for women and does not have a military component.

THE JOHNSON CHALLENGE. In 1998, Susan Phifer Johnson, Class of 1965, and George Dean Johnson Jr. made a pledge of $15 million if Converse could raise an additional $30 million in a few months time. Under the leadership of Board Chair William Barnet III, the challenge was met ahead of time. A new science and technology building will be named Phifer Hall. (Photograph by Stephen Stinson.)

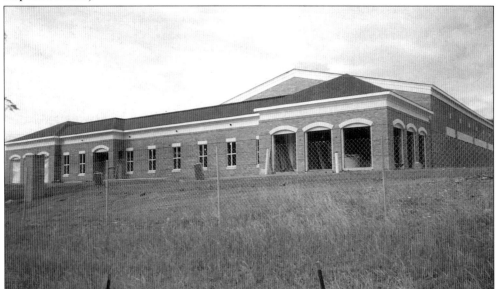

THE SALLY ABNEY ROSE PHYSICAL ACTIVITY COMPLEX AND WEISIGER CENTER. The new complex is located on North Fairview Avenue on land given by Ben Johnson and was funded by gifts from Ed and Agnes Binder Weisiger (Class of 1963) and the Abney Foundation in honor of Sally Abney Rose (Class of 1937). The Weisiger Fieldhouse is shown above in the summer of 2001 near its completion. New tennis courts and playing fields are also part of the complex.

126

NANCY OLIVER GRAY. Nancy Gray assumed her duties as president of Converse in the summer of 1999. She is a graduate of Vanderbilt University and had occupied a number of positions, mostly concentrating on institutional development. Immediately prior to coming to Converse, she was vice president of Seminary Relations at Princeton Theological Seminary, where she remains a trustee.

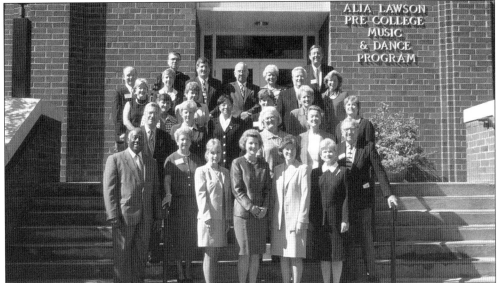

THE BOARD OF TRUSTEES 2001. The current board has been generous and vigilant. They are, from left to right, (front row) James Talley, Gay Colyer, Marsha Gibbs, Mary Belser (chair), Nancy Gray, and Julia Daniels; (second row) William Barnet, Marian Nesbet, Kay Woodward, Vicky Meyer, Jeanne Harley, and Robert Chapman; (third row) Lacy Chapman, Gillian Goodrich, Elise Warren, Patty Norman, and Margaret MacDonald; (back row) Steve Shepherd, Eloise Shepherd, Charlotte Verreault, Brant Bynum, Arthur Cleveland, Kurt Zimmerli, Jane Avinger, Thomas Hannah, George Dean Johnson, and Betty Montgomery.

In Deo Solo Confido

THE COLLEGE SEAL. Mary Wilson Gee obtained permission to use the Converse family coat of arms as the official seal of Converse College. The symbols on it are derived from medieval heraldry. The black band across the shield is a scarf of honor given for courage in battle. The trefoils (clovers) on the band symbolize the Christian Trinity and were given for service to the Church. The empty sleeves (maunches) were added to a coat of arms if a person had served as advisor to the king. The crest at the top is a mural gold crown out of which comes an arm. It could be used if a knight had climbed the walls of an enemy fortification and placed the king's standard or flag on top. The motto means "In God Alone I Trust."